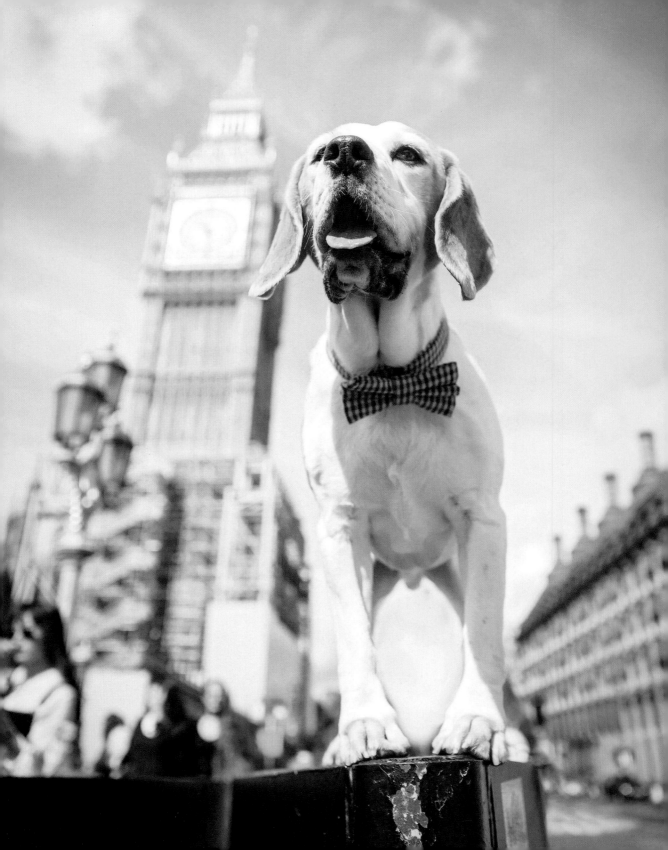

CANINES
OF
LONDON

PHOTOGRAPHS by BRIDGET DAVEY

TEXT by ANTONIA VAN DER MEER

Bluestreak
BOOKS

⫟Bluestreak

An imprint of Weldon Owen International
PO Box 3088
San Rafael, CA 94912
www.weldonowen.com

ISBN: 978-1-68188-505-6

First Printed in 2022
10 9 8 7 6 5 4 3 2 1
2022 2023 2024 2025

Printed in China

Edited by Julie Brooke
Designed by Dave Jones

Cover Image: Ginger, a Pembroke Welsh corgi

Weldon Owen would like to thank
Madeleine Calvi and Ian Cannon for their
editorial contributions to this book.

For Porthos

A big thank you to my husband,
Neil, for his huge support during this
project, for believing in me and in my
work, for carrying my backpack after
a long day, and for making me hot cups of
tea at the end of a busy shoot. Thank you
to my beagles, Porthos, Lucy, and Archie,
for their inspiration and their
endlessly wagging tails.

Introduction

If you met me on the street, you might wonder about my muddy shoes and my dirty knees, and the noises coming from my pockets. Most people wouldn't know that these are just the signs of my trade—dog photographer—that is, until they saw me in action. I am often found lying on the ground, making funny sheep noises, or waving a squeaky toy to get the attention of a dog for the perfect photo, one good enough to include in these pages.

To collect the amazing pictures for this book, I raced all over town. I could be found on the banks of the ice-cold Thames to snap a pooch's portrait on a dock, or on my knees in a puddle in the middle of Trafalgar Square to catch a dog's reflection in it, or crouching on a Chinatown street at sunset to get the best light on a golden retriever's shiny coat. If you love dogs and this awesome city, then this book is the *pawfect* combination of the two. (Sorry, I forgot to mention that I love puns almost as much as dogs.)

My love of dog photography started with my beagle pup, Porthos (his photograph is on page 2). My husband and I got him in 2008. He is the reason I do what I do. He was grumpy and tiny with the loudest bark. I began by capturing his daily life, his walks, and adventures. He showed me the world from a dog's point of view—how to sit on a bench, see the world go by, and be happy. Two years later, my second beagle, Lucy, moved in. She was the boss dog right away, but we had even more fun together. We explored Cornwall (they loved the beach); we went out for breakfast in London on a Sunday morning; we traveled to Paris, enjoying the French way of life, and I took the photo I'd always dreamed of taking: my two beagles at the Eiffel Tower.

Landmarks
page 8

Royal
page 48

Parks
page 64

The Thames
page 94

Neighborhoods
page 122

I soon realized that my pictures could be helpful as well as entertaining, so I started working with dog rescues, photographing the not-so-lucky ones and helping them find their *fur-ever* homes.

Working in London with dogs is a dream, but it can also be challenging. We were on busy streets, and there were lots of distractions—enticing smells, interesting people, quacking ducks, and wily squirrels. All the noise and activity made it difficult to keep the pups focused and calm. If you see it from their perspective, even rolling luggage can be scary. And then, of course, there were the challenges of the British weather, which can change from a sunny afternoon to a rain storm in five minutes. But apart from these things, London is a pretty cool place for photography. It is truly a fabulous backdrop for showcasing my tail-wagging heroes and furry companions—posed everywhere from shiny skyscrapers to historic palaces, from the green grass of the city's parks to the colorful, front doors of many London homes. I got to explore so many new areas along the way, finding new secret spots. But best of all, I got to see the city from a dog's perspective. Through these pages, you can, too.

In all, I photographed 165 dogs, walked 296.7 miles, took 190 Tube rides, handed out 40 bags of dog treats, and wore through 3 pairs of shoes. The dogs were mostly from London, but many others traveled here for their photo shoots. This book includes canines from about thirty different nations in Europe, Asia, South America, and North America. All of them were simply outstanding subjects. Some were seasoned models, but for others it was their first time in front of a camera. From a tiny mi-ki to a big Czechoslovakian wolf dog—four paws up to them all. It was a huge effort, but through it, I met the most amazing people and their dogs. I want to say a heartfelt thanks *fur* everything to those who took part and made time in their busy lives (both human and canine) to explore London with me. Without your help, this project would never have come to fruition.

Sadly, Porthos had to go over the Rainbow Bridge at the end of last year. But his soul and his happy nature live on. Without him, *Canines of London* would not have happened. He was, and he still is, my heart dog. We have a new little addition to our family now, named Archie. You can see his photo in Trafalgar Square with the big lion statue on page 21. He is such a happy little chap. And we have lots of adventures to look forward to with him and Lucy.

This city is very dog-friendly, so hopefully you will be inspired to explore it with your own pets. If you see me on the street (besides the muddy clothes, you may notice my pink hair), stop and watch for a while. But I doubt you will pay much attention to me, just another member of the pupparazzi. More likely you'll be focused on the furry friends at the other end of my lens. They are the true stars.

Bridget and the Beagles (Porthos, Lucy, and Archie)

LONDON
Landmarks

When a man is tired of London, he is tired of life;
for there is in London all that life can afford.

—Dr. Samuel Johnson

ROLO
Miniature Dachshund

Houses of Parliament and Big Ben

@rosadiposa

Rolo loves the limelight! He'll do anything to be in front of the lens. His favorite treat is cheese; he can sense you thinking about it before you even open the fridge door.

LUCY and PORTHOS
Beagles

Buckingham Palace

@tails_of_two_beagles

TESS
Golden English
Cocker Spaniel

The Mall

@TessAboutTown

HATTIE
Chihuahua

Buckingham Palace

@hattiekin

HANK

Pembroke Welsh Corgi

Buckingham Palace

@the_corgi_hank_scorpio

The Queen isn't the only famous resident of Buckingham Palace. She has almost always lived in her 775-room home with her beloved corgis and dorgis (a corgi–dachshund mix). Sadly, Hank is no relation. He prefers playing with sticks and rolling in the mud. But posed here—with a clean coat and bright eyes— he looks just like royalty.

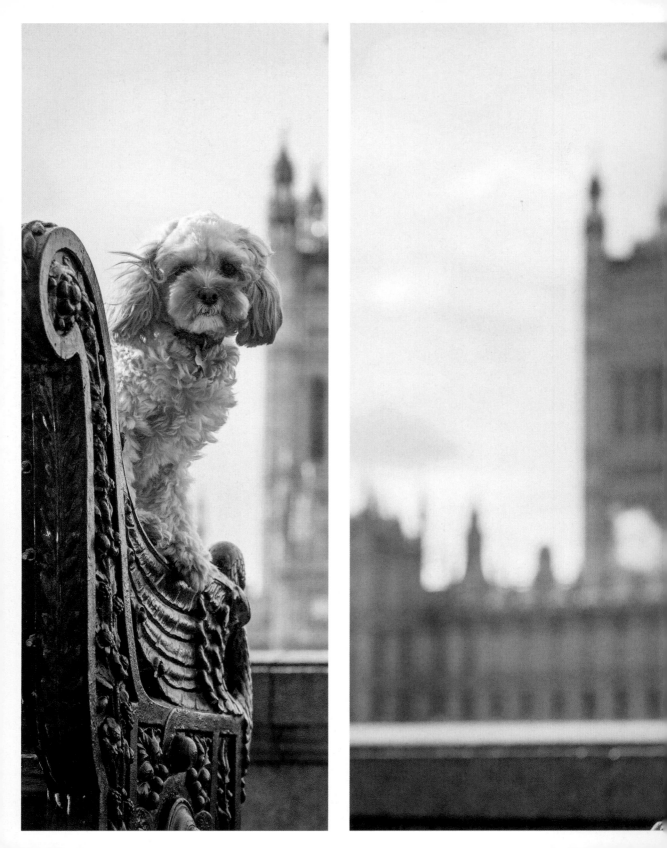

SAPHY

Cavapoo

Houses of Parliament

@saphythesplendiferous

Saphy lives in central
London and enjoys chewing
rope toys, watching TV,
eating fish, long walks,
and snuggling.

HUXLEY and ROLO

Miniature Dachshunds

Houses of Parliament and Big Ben

@rosadiposa

Huxley (the beautiful blonde) and Rolo (the handsome brunette) pass the time in front of Big Ben. They are best friends and partners in crime.

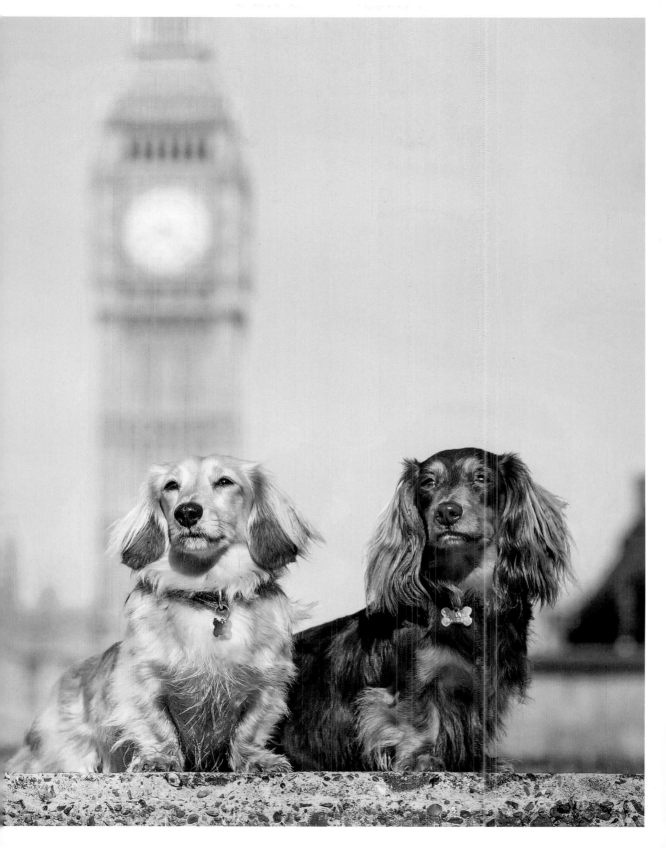

FRANK

Puggle

Victoria Tower,
Westminster

@_frank_and_penny_

In the background, the
Palace of Westminster
is where the House
of Commons and the
House of Lords sit.
Sitting here, this little
lord is proud to be a
puggle, a mix between
a beagle and a pug.

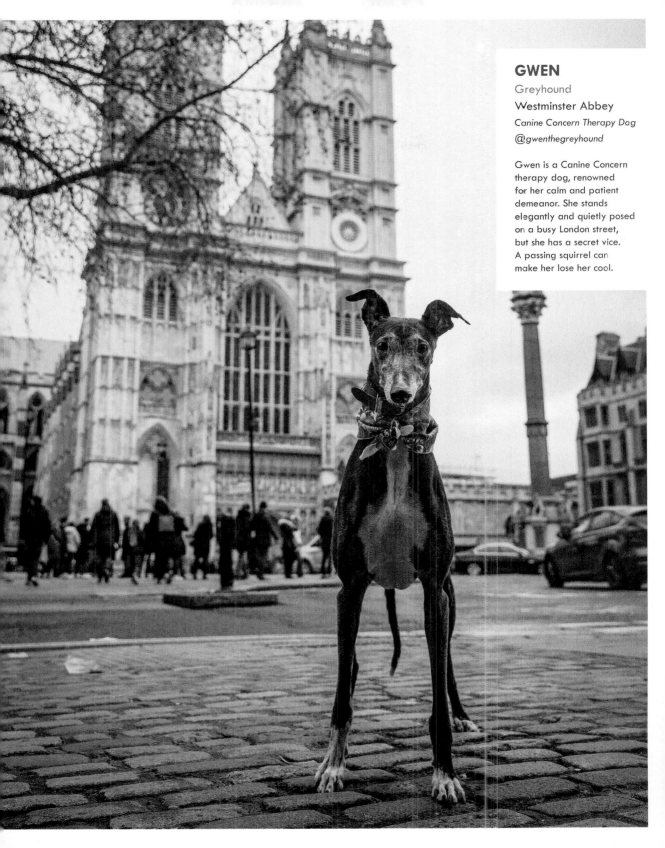

GWEN

Greyhound

Westminster Abbey

Canine Concern Therapy Dog

@gwenthegreyhound

Gwen is a Canine Concern therapy dog, renowned for her calm and patient demeanor. She stands elegantly and quietly posed on a busy London street, but she has a secret vice. A passing squirrel can make her lose her cool.

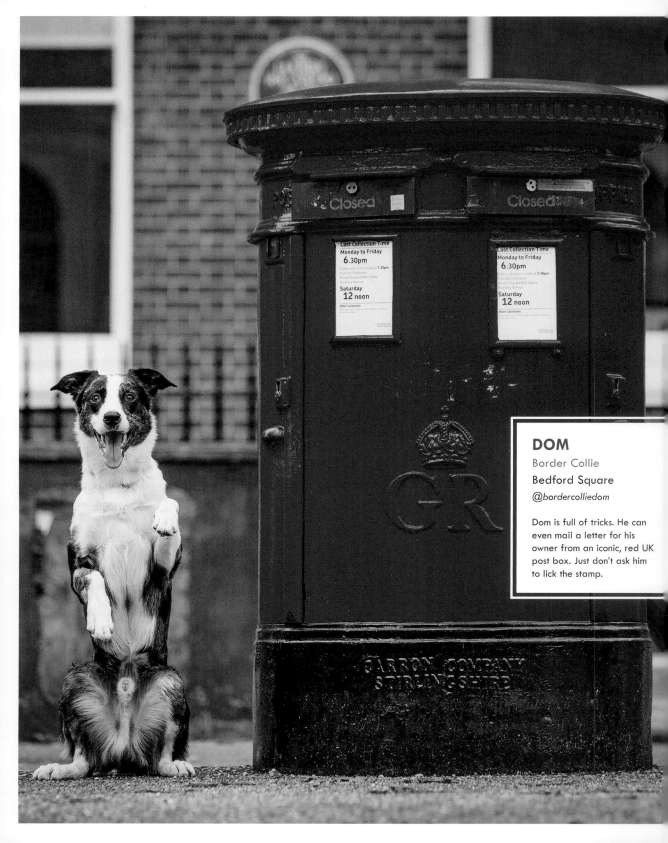

DOM
Border Collie
Bedford Square
@bordercolliedom

Dom is full of tricks. He can even mail a letter for his owner from an iconic, red UK post box. Just don't ask him to lick the stamp.

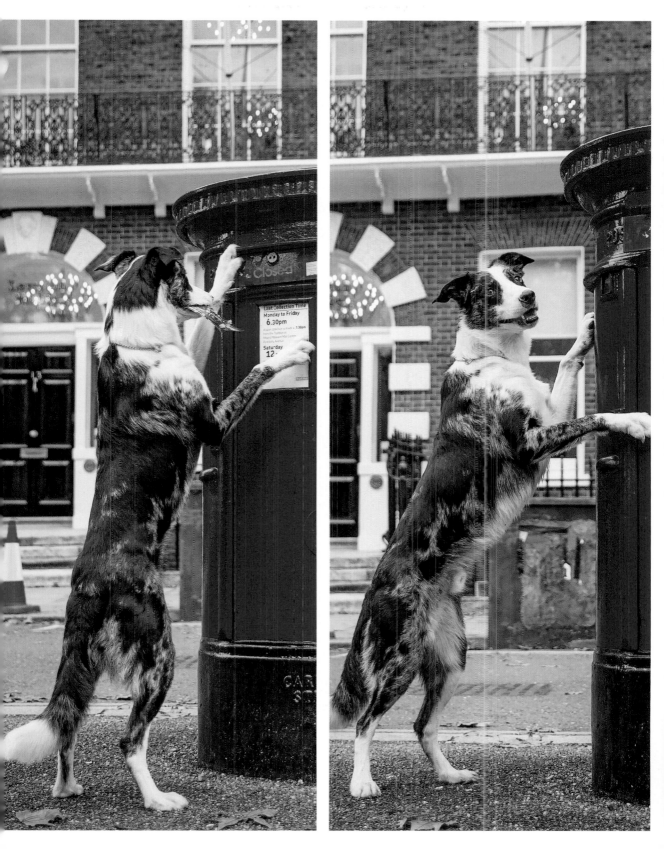

HANK

Pembroke Welsh Corgi

Trafalgar Square

@the_corgi_hank_scorpio

One dog's puddle
is another's mirror.
Looking good, Hank!

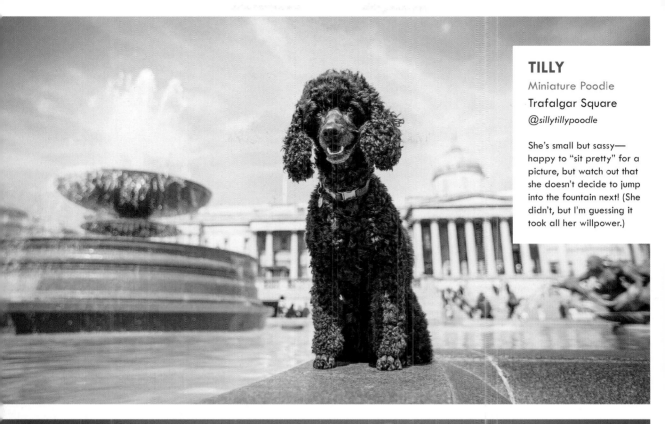

TILLY
Miniature Poodle
Trafalgar Square
@sillytillypoodle

She's small but sassy—happy to "sit pretty" for a picture, but watch out that she doesn't decide to jump into the fountain next! (She didn't, but I'm guessing it took all her willpower.)

ARCHIE
Beagle
Trafalgar Square
@tails_of_two_beagles

Fifteen-week-old Archie befriends one of the famous lions of Trafalgar Square that surround Nelson's Column. He finds good buddies everywhere he goes.

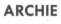

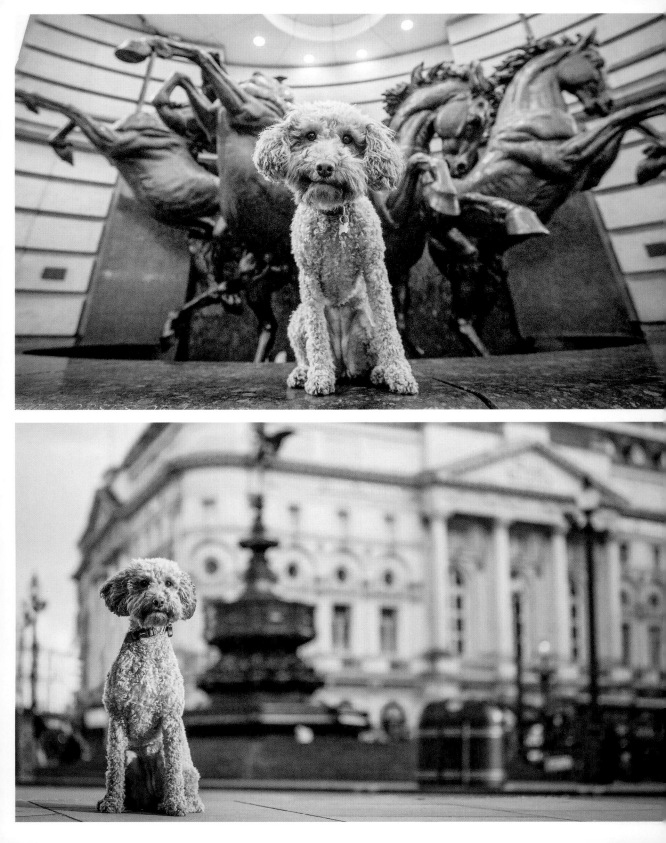

PEGGY
Miniature Labradoodle
Piccadilly Circus
@Peggythedood

By day, Peggy likes the hustle and bustle of Piccadily Circus. At night, she waits for her people to fall asleep and then sneaks into their bed to sleep with them. She dreams of catching squirrels.

LOVE, MUSIC, and ANGEL

Golden Retrievers

Chinatown

@goldenretrievers8

These three gorgeous goldens aren't related but they are family now. Love (center) is the biggest, but thinks she's small enough to curl up in her owner's lap. Shy Angel (left) is Love's shadow, while Music (right) is an ardent fan of water pistols. She loves catching the water in her mouth.

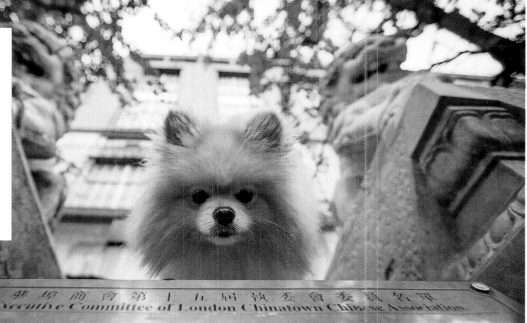

THOR

Pomeranian

Chinatown

@thor.pom.pup

This fierce little diva has a real sense of humor. He steals dirty socks from the laundry basket and hides them all over the house. He wakes up his daddy in the morning by sitting on his head and licking his ears.

DJ

Boston Terrier

Chinatown

@dj_bostonterrier

The friendliest pup ever, DJ adores music and dancing—he's a bundle of energy, always ready to spring into action. He can't get enough of playing fetch with his toys.

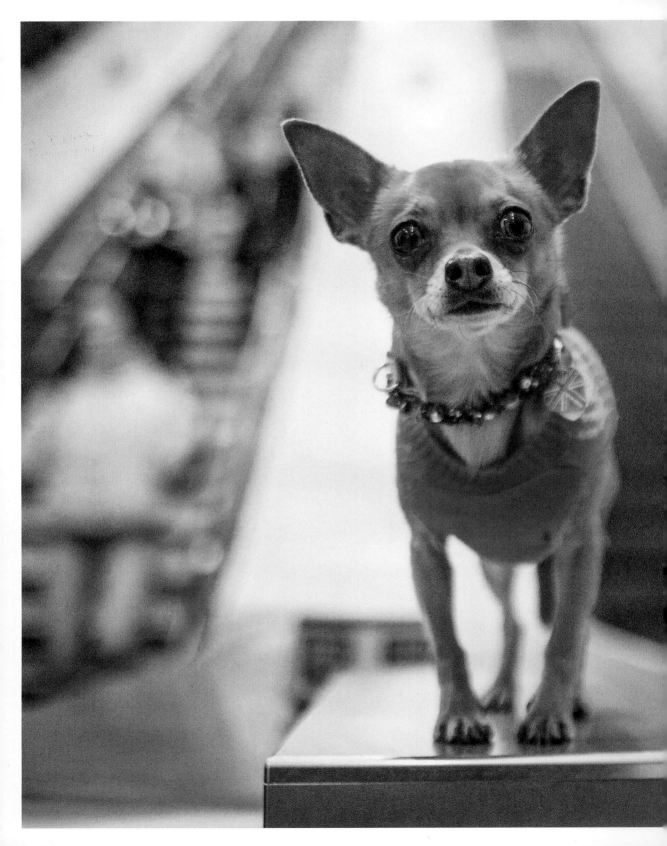

POPPY
Chihuahua

Piccadilly Underground Station

@poppy_pantsface

Poppy is a proud mascot for her mom's business—@catsdogphotography—and her bodyguard during photo shoots.

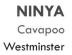

NINYA
Cavapoo
Westminster

This super-cute, fluffy, white furball is four years old, and born to cuddle. She prizes her snacks, too. If you've got cheese, you've got her attention.

BELLA and BEAR
Havanese
Central London
This pair both love to chase squirrels.

HERBIE
Beagle
Green Park

CLAUDE
Golden Retriever
Whitehall

@the_life_of_claude_and_elmo

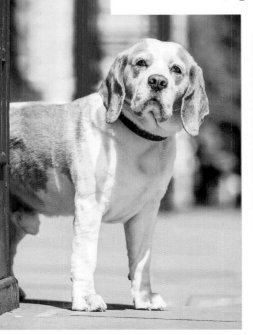

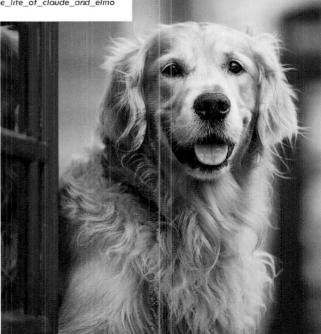

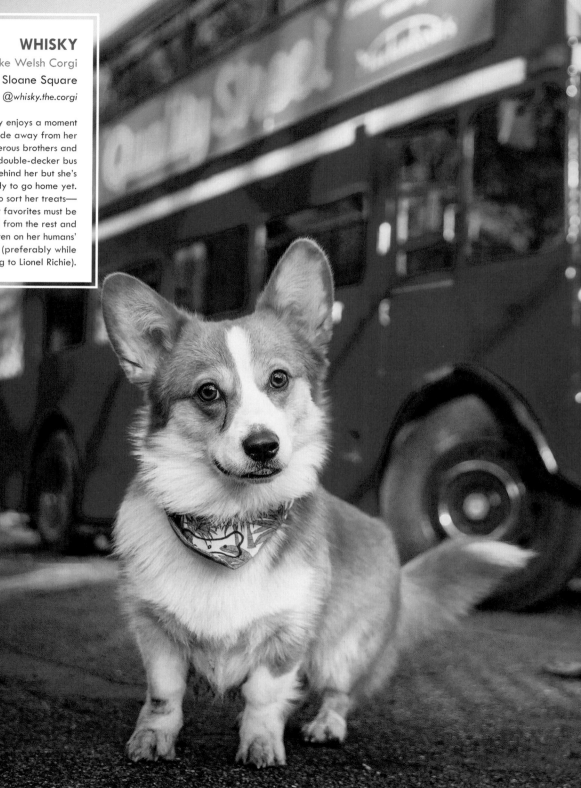

WHISKY
Pembroke Welsh Corgi
Sloane Square
@whisky.the.corgi

Whisky enjoys a moment of solitude away from her nine boisterous brothers and sisters. A double-decker bus passes behind her but she's not ready to go home yet. She likes to sort her treats—her favorites must be separated from the rest and then eaten on her humans' bed (preferably while listening to Lionel Richie).

PAX

Whippet

Brick Lane

@pasitopax

Pax greets his humans every morning with his happy howling—*roorooroo!* He's a real joy to be around. He is shown here hanging out in front of The Black Cab Coffee Co., an old London taxi that has been transformed into a cool coffee shop. Unfortunately, the things he likes—avocado, cucumber, coconut oil, and raw meat—are not on the menu here. A sun worshipper, he is always happy to be outside in good weather.

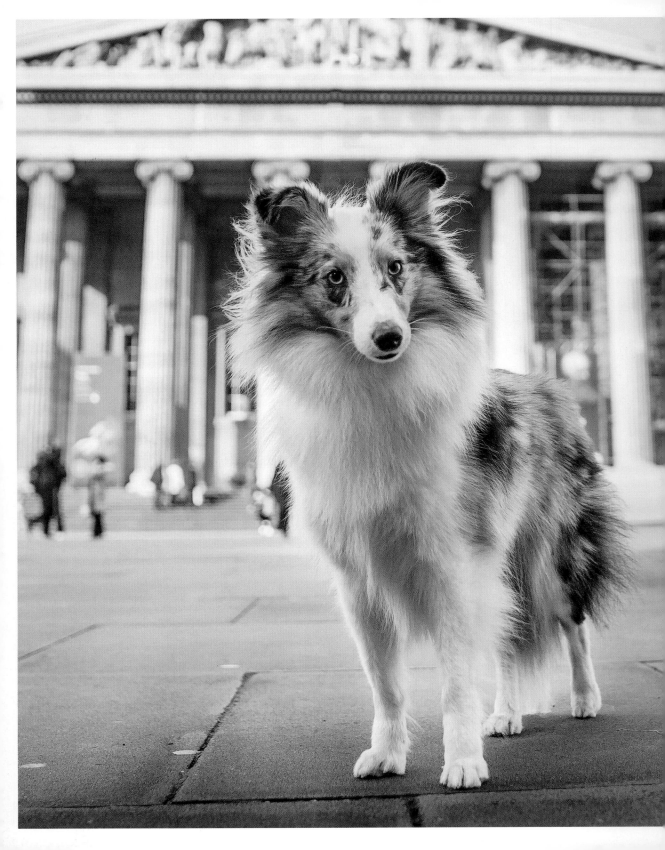

QUINN
Shetland Sheepdog

British Museum

@savendieshelties

I tend to photograph dogs early in the morning when there aren't many people around and there are few distractions. With one-year-old Quinn, however, it wouldn't have mattered how busy the scene behind her was. She is extremely well-trained. Her owner told her where to stand and that's where she stood. Not all dogs make it this easy to get the shot!

NALA
Miniature Dachshund
London Eye
@nala.the.dachs

Nala is just eight months old. But she's already an old hand at stealing hearts and winning smiles.

SAPHY
Cavapoo
London Eye
@saphythesplendiferous

Saphy thinks she's the top tourist attraction in London. Nobody has told her that it's actually the giant wheel behind her.

MYSZA

German Shepherd Mix

London Eye

@mysza_the_dog

This busy area is often clogged with visitors queuing up for a ride on the London Eye. You can hear a multitude of languages in the space of a few minutes. Mysza herself speaks two, and responds to commands in both Polish and English.

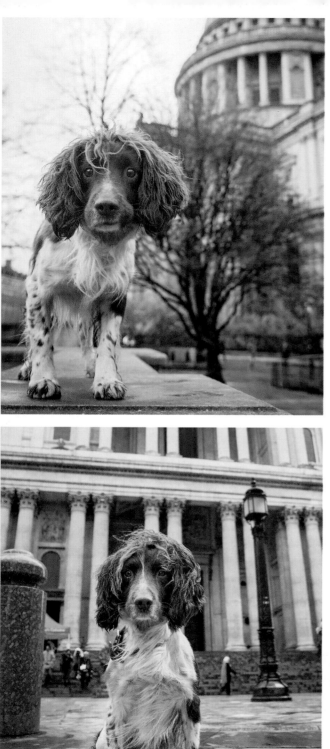

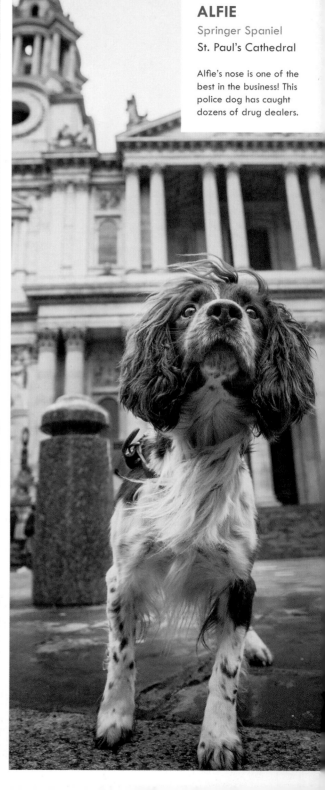

ALFIE
Springer Spaniel
St. Paul's Cathedral

Alfie's nose is one of the best in the business! This police dog has caught dozens of drug dealers.

KIN
Japanese Akita Inu
St. Paul's Churchyard
@robertstuhldreer

KIN

Japanese Akita Inu

Shakespeare's Globe

@robertstuhldreer

Kin is a professional canine actor who, with her friend Flora (pictured at right), has starred in film, TV, and theater productions. Both dogs represent their respective breeds at national events. Flora has won several awards, including for acting, but she finds Shakespeare a real yawn.

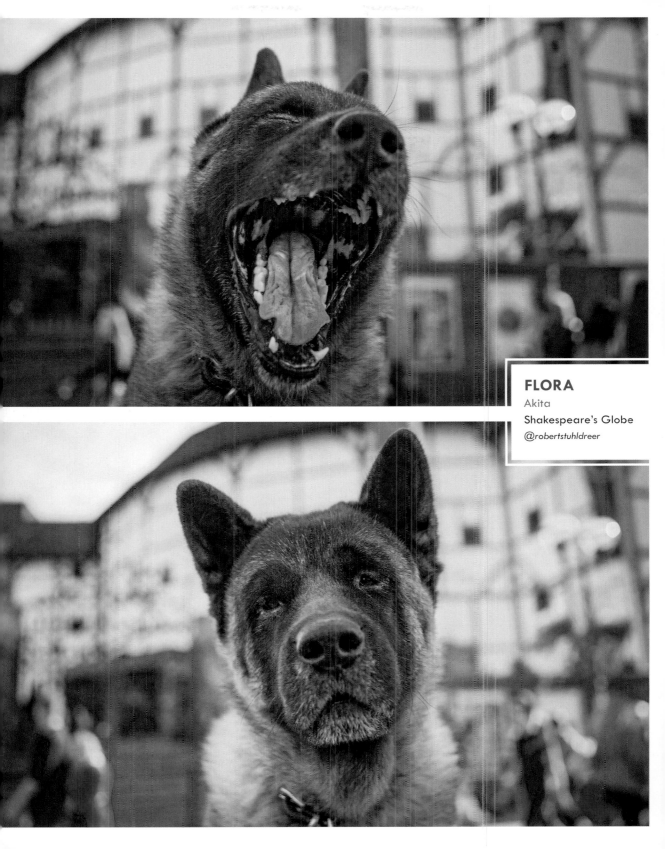

FLORA
Akita
Shakespeare's Globe
@robertstuhldreer

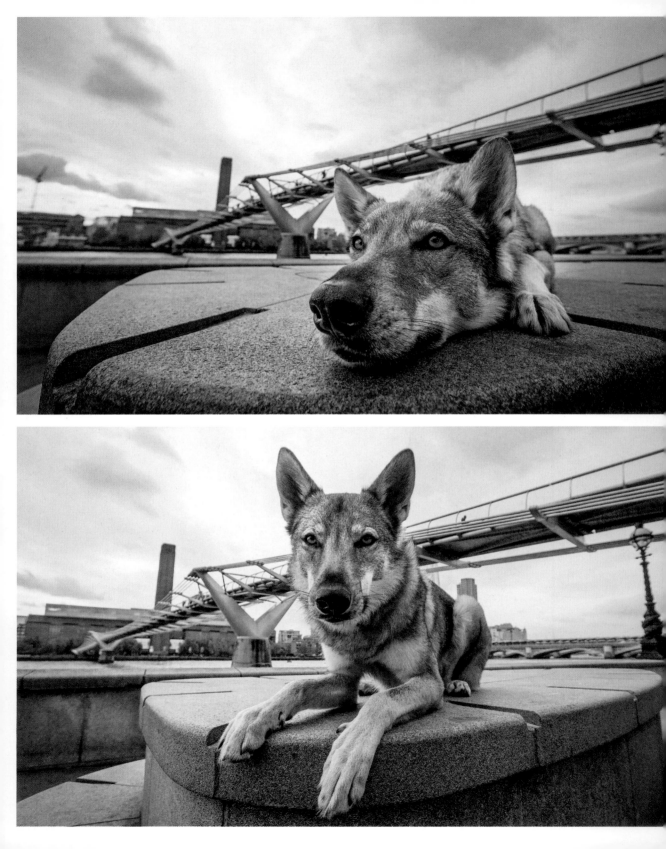

VULRIC

Czechoslovakian
Wolfdog

Millenium Bridge

@wolfdog_of_london

Sometimes when I am
shooting a dog, people
stand behind me and
take pictures with
their phones. It can be
distracting for the dogs.
But not Vulric. He is super
well trained. He knows
forty tricks including play
dead, wave, and stand
on your hind legs. He
could have posed all day!

CHINO
Tibetan Terrier
Tower Bridge
@michelle_and_chino

JASPER
Shorkie
Tower Bridge
Viewing Platform
@jasperexplores

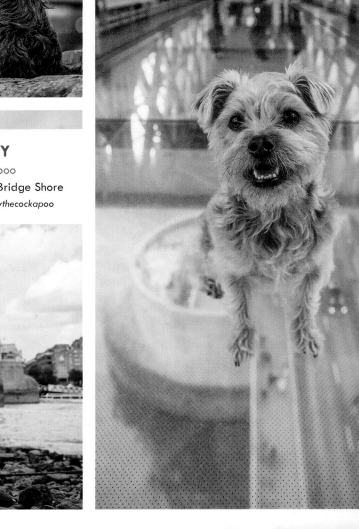

PERCY
Cockapoo
Tower Bridge Shore
@percyythecockapoo

BENTLEY
Bulldog Mix
Tower Bridge
@Bentley_the.bully

Bentley's blue, merle coat looks great against the sky-blue of Tower Bridge. When he's not being a magazine cover star, he loves playing with his people.

GINGER

Pembroke Welsh Corgi

Tower Bridge

@gingerfluffycorgi

Ginger demands scratches
by headbutting his human's
hand. Clever boy.

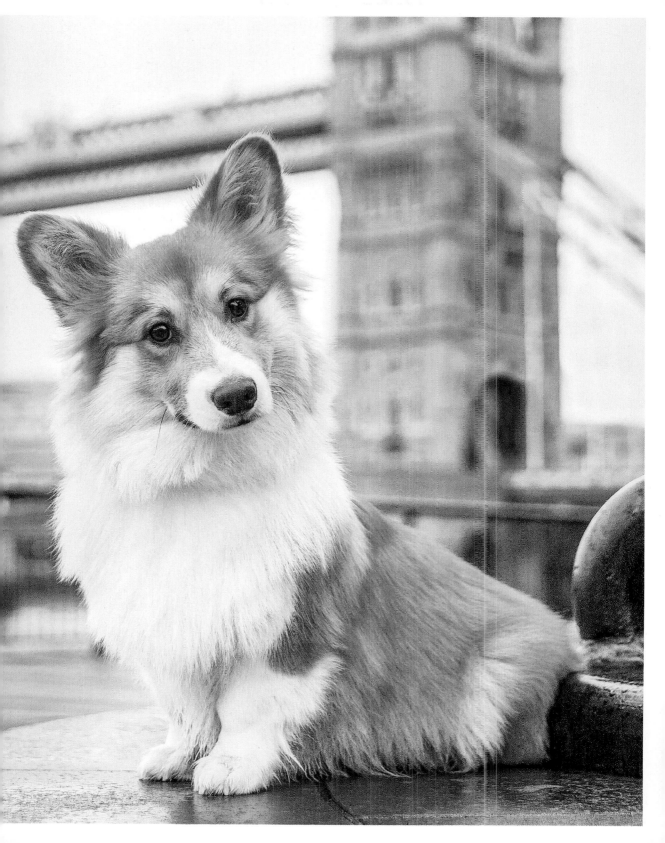

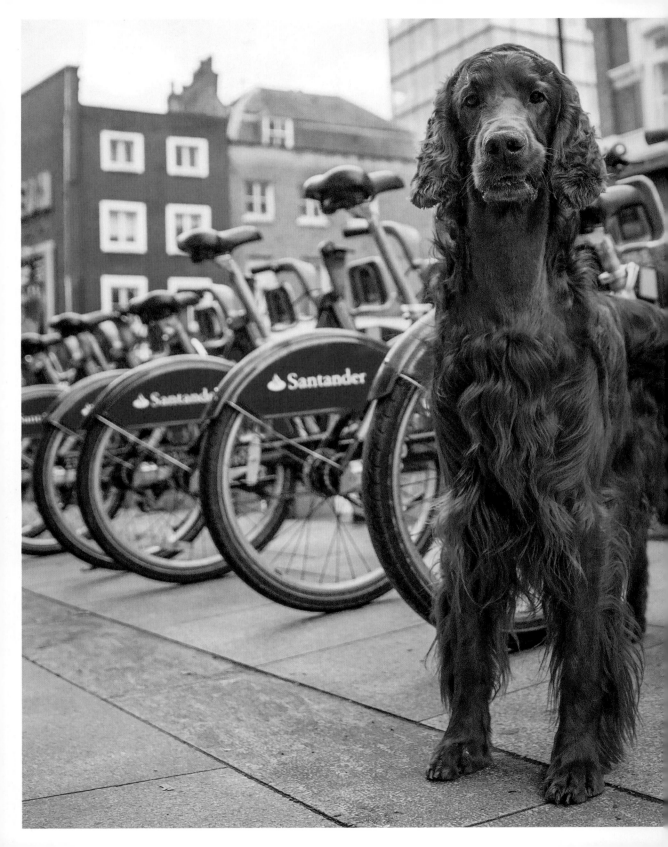

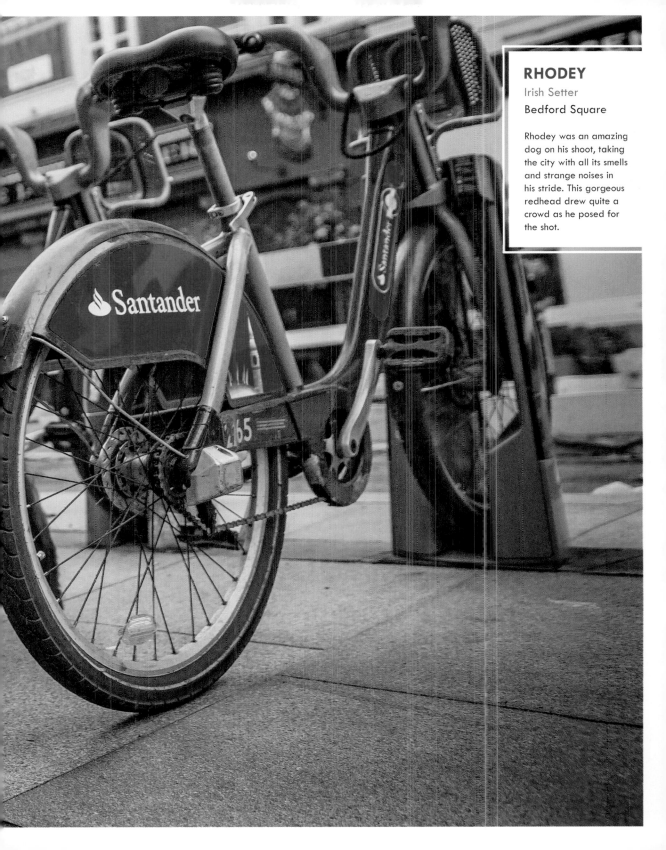

RHODEY
Irish Setter
Bedford Square

Rhodey was an amazing dog on his shoot, taking the city with all its smells and strange noises in his stride. This gorgeous redhead drew quite a crowd as he posed for the shot.

Royal
LONDON

This royal throne of kings, this sceptered isle,
This earth of majesty; this seat of Mars.

—William Shakespeare, *Richard II*

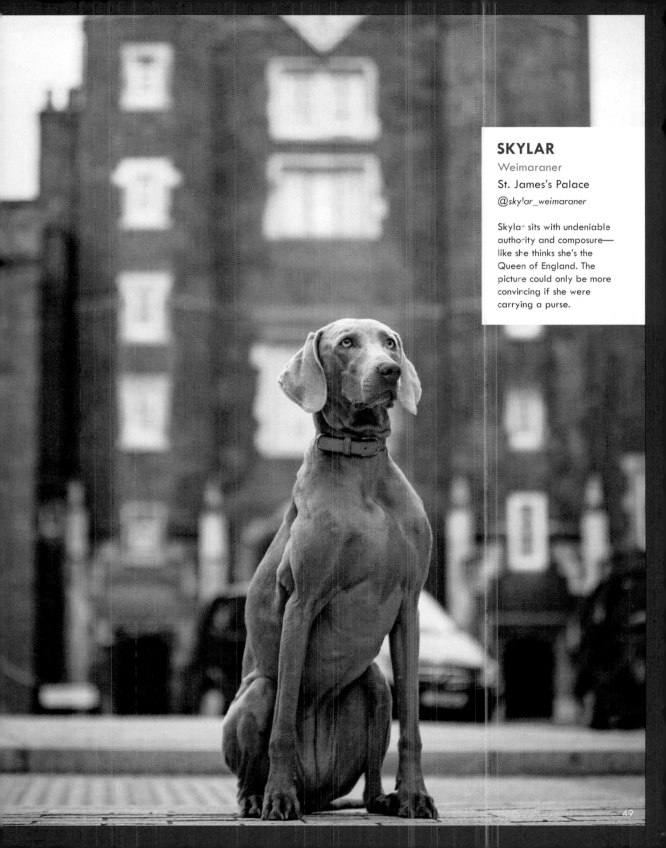

SKYLAR

Weimaraner

St. James's Palace

@skylar_weimaraner

Skylar sits with undeniable authority and composure—like she thinks she's the Queen of England. The picture could only be more convincing if she were carrying a purse.

MAYA

Yorkshire Terrier

Buckingham Palace

All Dogs Matter Rescue Dog

@mayachanlondon

Maya enjoyed her life
in London but is now
exploring her new
kingdom—Tokyo.

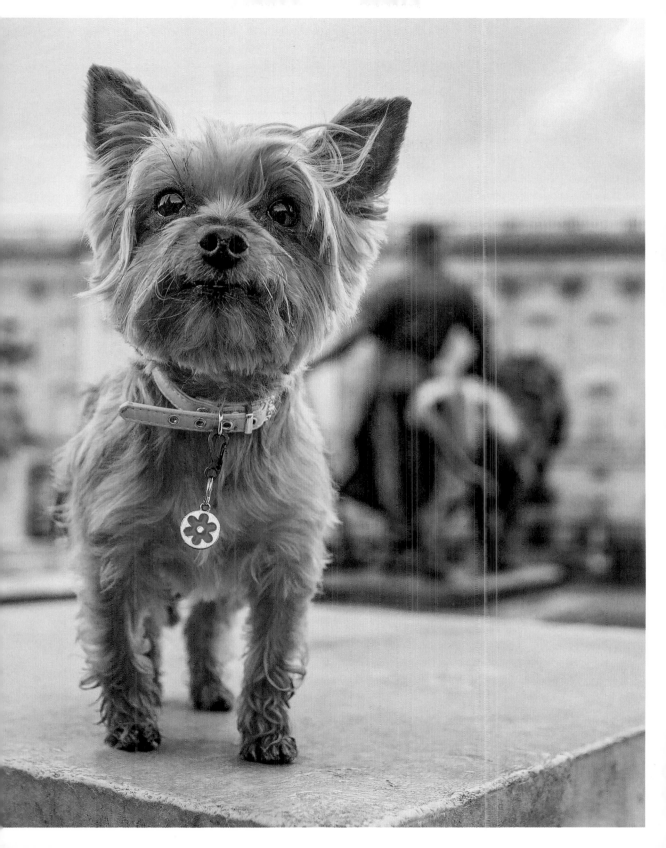

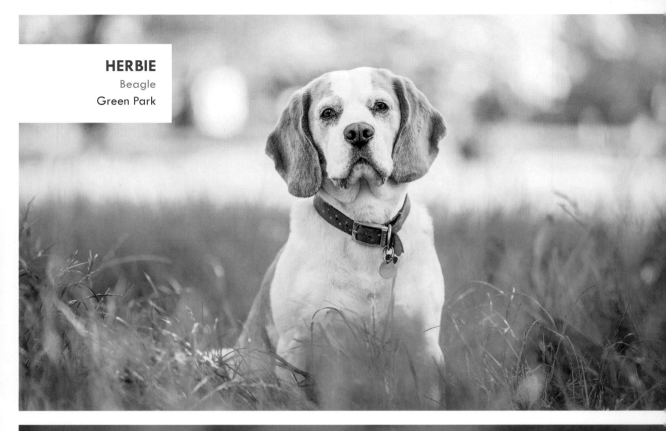

HERBIE
Beagle
Green Park

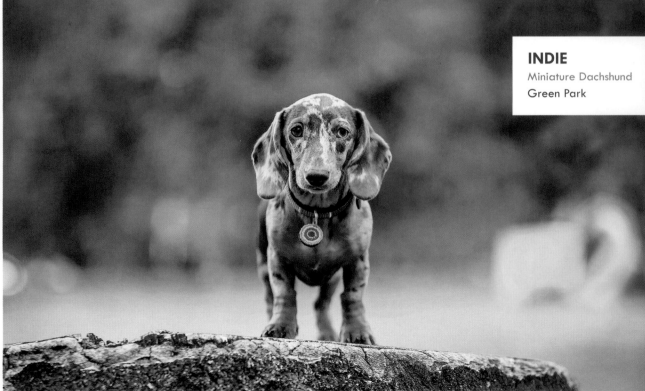

INDIE
Miniature Dachshund
Green Park

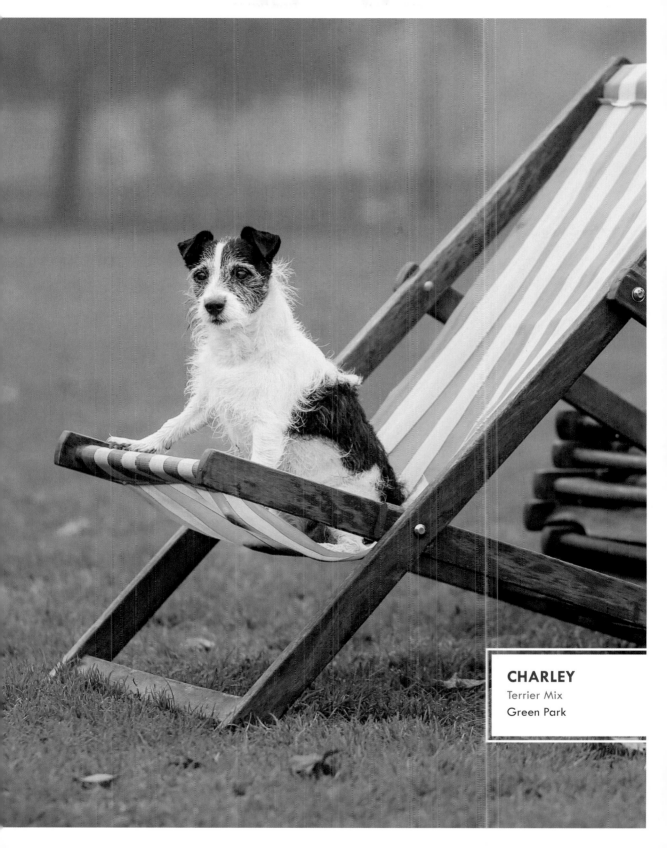

CHARLEY
Terrier Mix
Green Park

TILLY

Miniature Poodle

Horse Guards Parade

@sillytillypoodle

There's no better place for a little fancy prancing than the parade grounds in Central London where annual historic ceremonies like Trooping the Color take place. High-stepping Tilly is out to prove that she has the right stuff.

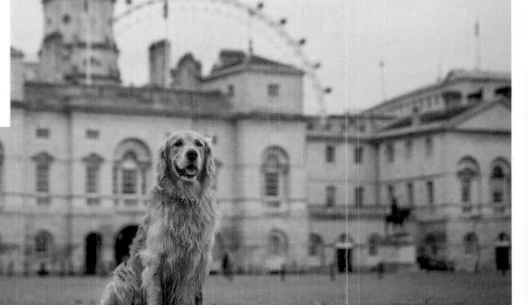

CLAUDE

Golden Retriever

Horse Guards Parade

@the_life_of_claude_and_elmo

This brave dog survived
a brain tumor and is
making the most of life!

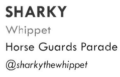

SHARKY

Whippet

Horse Guards Parade

@sharkythewhippet

Although whippets have
historically been bred for racing,
Sharky doesn't mind standing
still for his photo. Never one
to like the cold, he's relieved
he has on his handsome,
windowpane-plaid coat today.

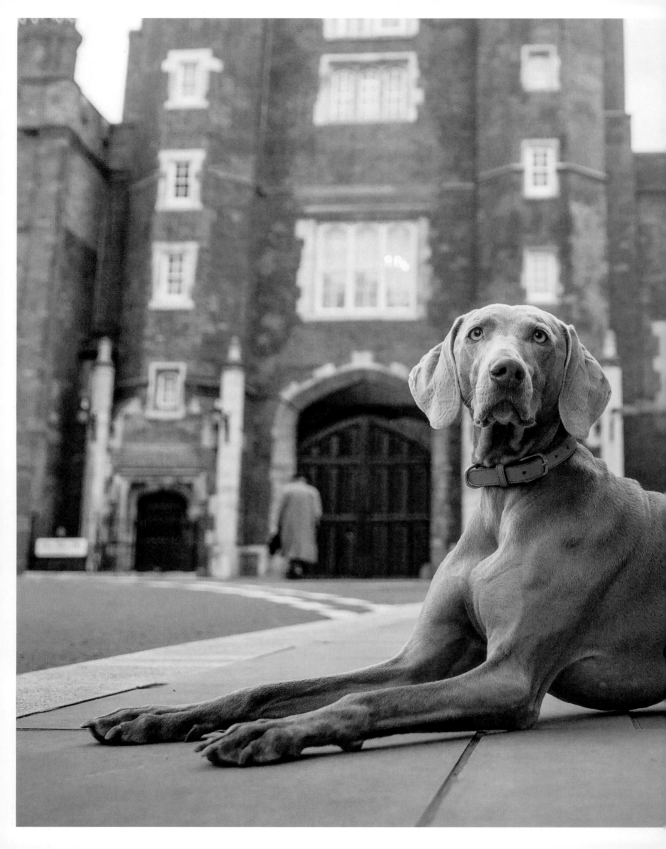

SKYLAR
Weimaraner
St. James's Palace
@skylar_weimaraner

Skylar loves the camera!
She's appeared in over
fifteen ads and has
worked as a model
for global brands, but
success hasn't gone to her
head. She's still happy to
play it cool.

DAPHNE
Chiweenie

St. James's Park

@daphnethewondersossige

Part-time model and full-time diva, Daphne is a short-legged, big-eared supermodel and socialite who loves pretty pink things. This dachshund—chihuahua mix supports rescue dogs and donates her modeling fees to them.

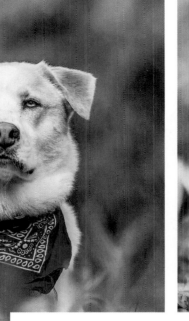

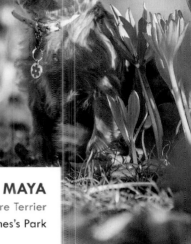

SKYE
Husky Mix
St. James's Park
@supermutt_skye

MAYA
Yorkshire Terrier
St. James's Park

GERTIE
Schnauzer
St. James's Park

HERBIE
Beagle
St. James's Park

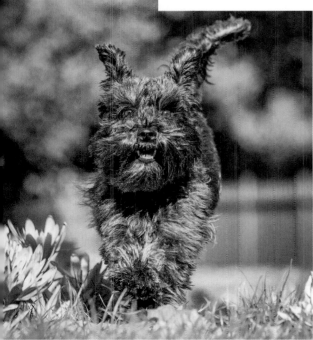

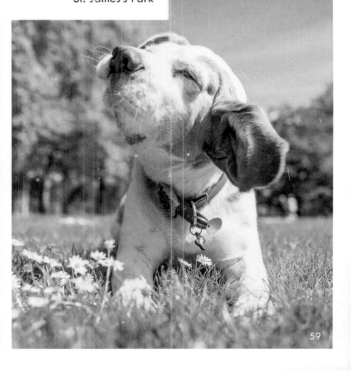

SOOK

Mixed Breed

Albert Memorial

Street Dog from Thailand

@sook.the.thai.rescue

Sook was a street dog in Thailand before she was rescued by an elephant sanctuary. She later came to the UK after her mom fell in love with her while on vacation.

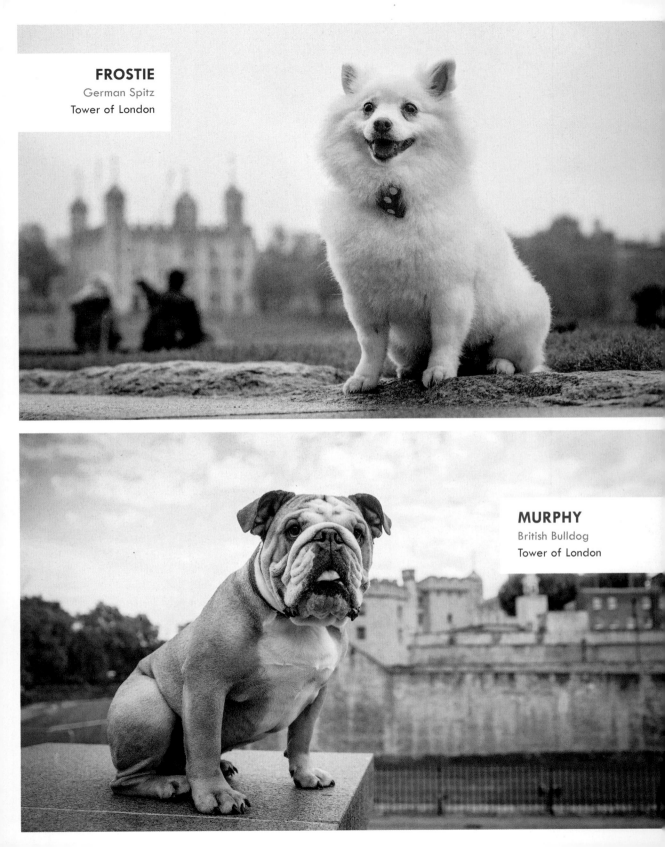

FROSTIE
German Spitz
Tower of London

MURPHY
British Bulldog
Tower of London

BOFFI

Cavalier King
Charles Spaniel

Tower of London

@Cavalier_boffi

Boffi lives in Spain but
was born and raised
a Londoner. The warm
sunlight on her uplifted
face reminds her of
home, but while traveling
she always has a nose
for adventure.

LONDON

Parks

Oh, to be in England now that April's there.

—Robert Browning

FINN
German Shepherd
Victoria Park

Finn enjoys a welcome escape from the city as he plunges into the pond at Victoria Park. When he's not thrashing about in the water, Finn loves chasing balls and squirrels.

CYBYLL
French Bulldog
Hyde Park

When the sun's shining, Cybyll thinks the best place to be is in the park, playing with her humans. That's a face no one would argue with.

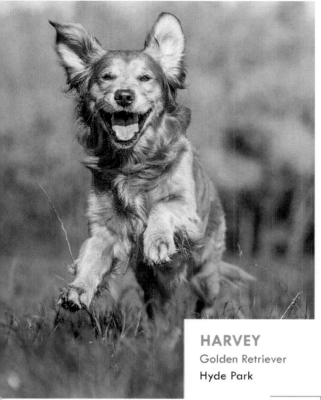

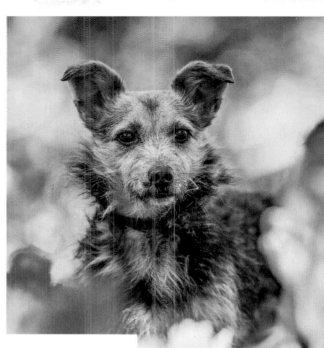

HARVEY
Golden Retriever
Hyde Park

TIMMY
Terrier Mix
Victoria Gardens

WALTER
Bassett Hound
Richmond Park

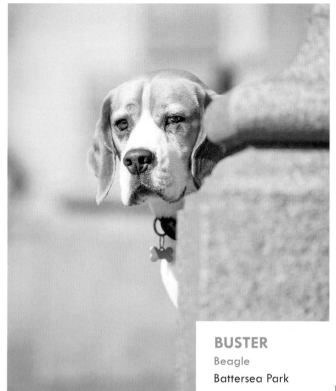

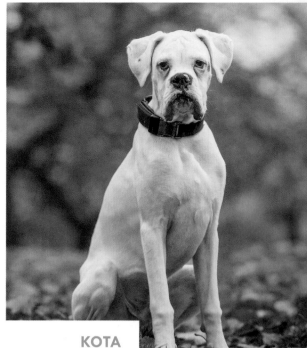

BUSTER
Beagle
Battersea Park

KOTA
White Boxer
Kensington Gardens

BESSIE
Mixed Breed
Battersea Park

GUS
Terrier Mix
Battersea Park

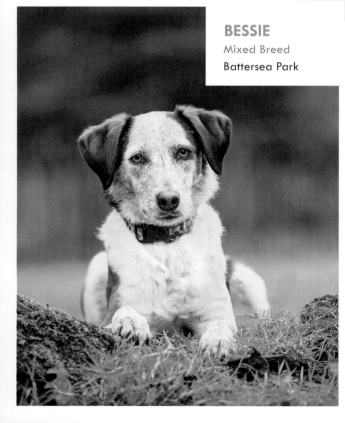

AOIFE
Staffordshire Bull Terrier
Battersea Park

When she's in need of some quiet reflection, Aoife stops at the London Peace Pagoda, but not for long. Staffordshire bull terriers like Aoife are too playful and friendly to spend much time alone.

KYLO

Jack Russell Mix

Battersea Park

@kylothejackapoo

This high-energy pup makes the most of city life by visiting one of the city's biggest parks.

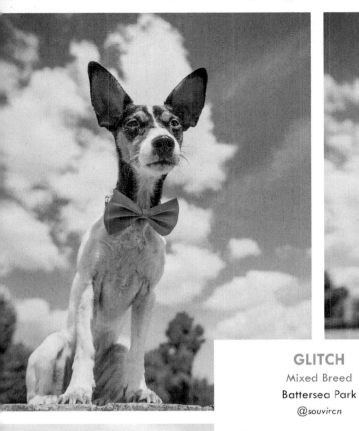

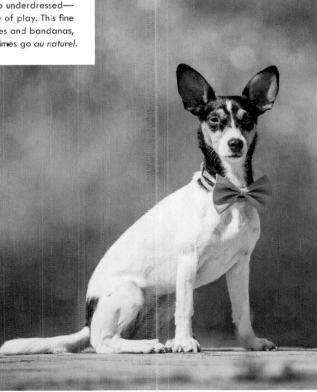

GLITCH
Mixed Breed
Battersea Park
@souvircn

Glitch rarely shows up underdressed—
even for a casual day of play. This fine
fellow loves his bowties and bandanas,
although he will sometimes go *au naturel.*

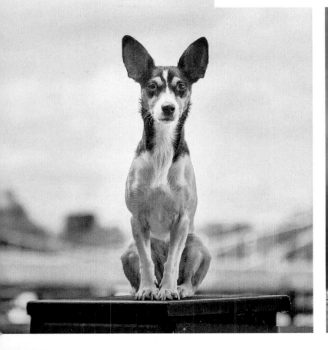

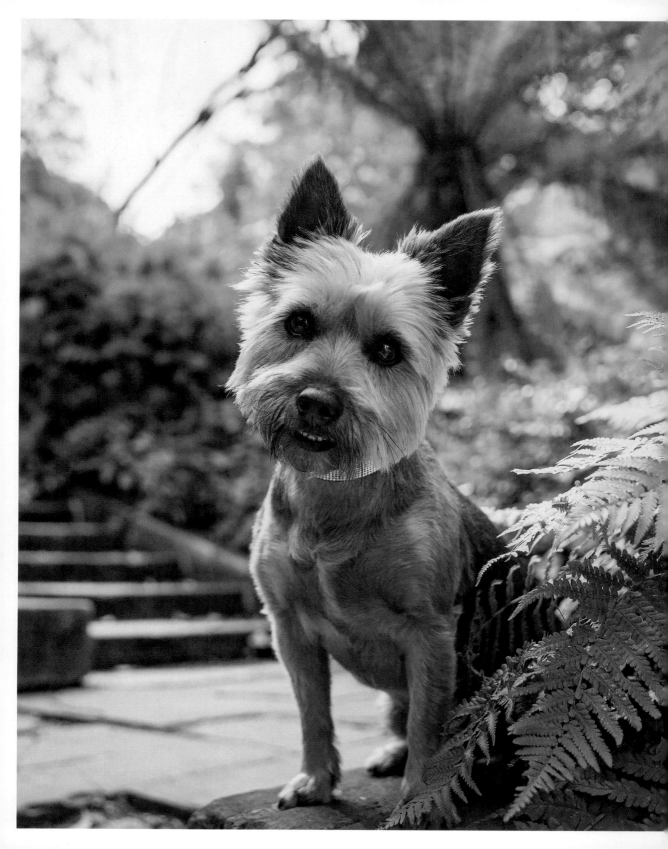

CC
Yorkshire Terrier
Holland Park

There's nothing CC likes more than a game of oversize chess in the park. This little lady remains calm under pressure, but if a squirrel scoots by, it's game over!

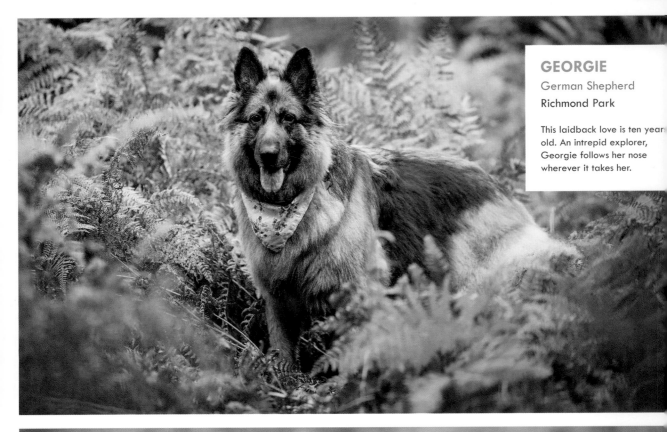

GEORGIE
German Shepherd
Richmond Park

This laidback love is ten years old. An intrepid explorer, Georgie follows her nose wherever it takes her.

FERGUS and DEXTER
Corgis
Greenwich Park

Two brothers, happy companions, each think they are the more handsome of the two. One thing they can agree on, however—life is good at Greenwich Park.

MILLIE
Cavapoo
Greenwick Park

Freedom at last! A sunny day is the perfect time for explosive fun. Millie is off the leash for no more than a moment and ... lift off!

DECI
Bernese Mountain Dog
Kensington Gardens

Lovable and alert,
Deci likes to multitask.
That's lucky as there's
always a lot going on in
her home, which she
happily shares with her two
sisters and two cats.

MILLY
Mixed Breed
Kensington Gardens

GUS
Terrier Mix
Battersea Park

DOMINO
Dalmatian
Kensington Gardens

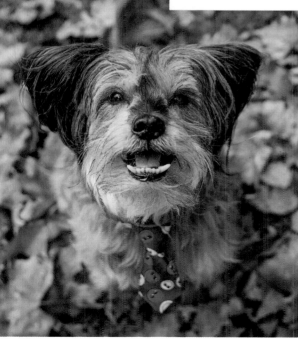

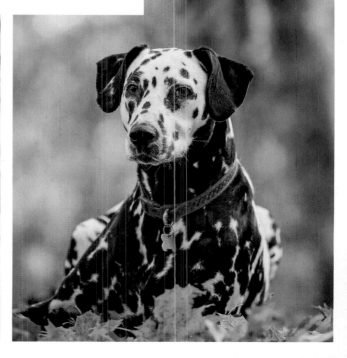

DOM
Border Collie
Colville Place
@bordercolliedom

No one can resist those eyes! When Dom asks you to play, the answer is always, "Yes!" Border collies like Dom are happiest when they're active and engaged.

DEXTER
Corgi
Greenwich Park

BEAU
Shar-Pei
Southwark Park

BUDDY
Australian Labradoodle
Regents Park

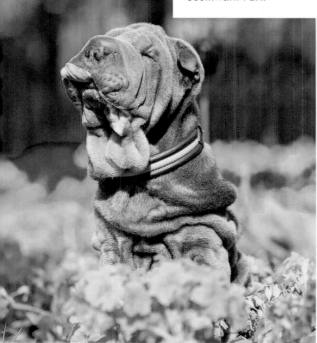

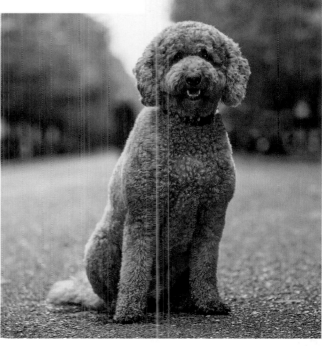

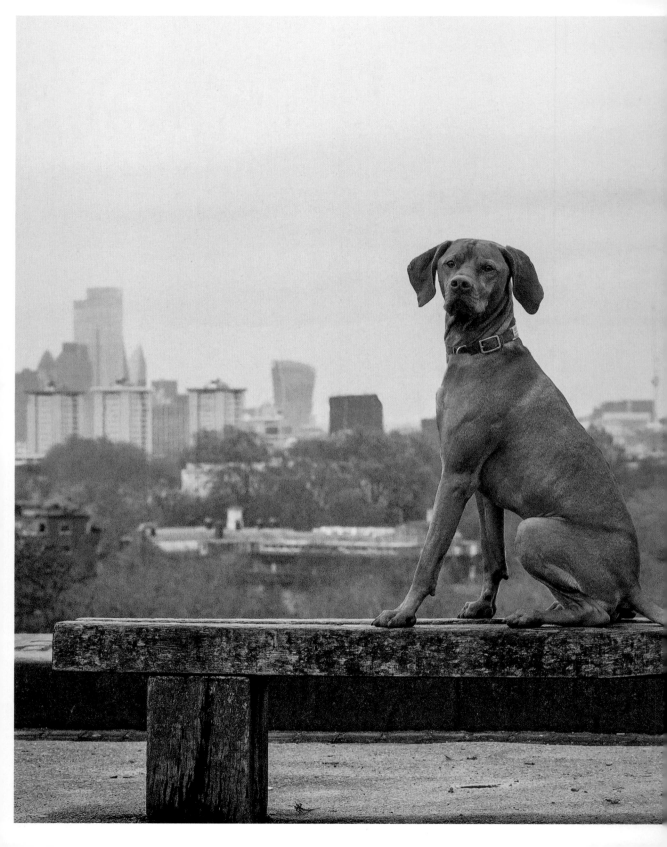

MOOSE

Vizsla

Primrose Hill

@moosetheviz

Moose adores having his picture taken. Frankly, he's a bit of a ham. Sure, he looks quite dignified and regal, but he can quickly dissolve into a goofball if you give him an ear rub.

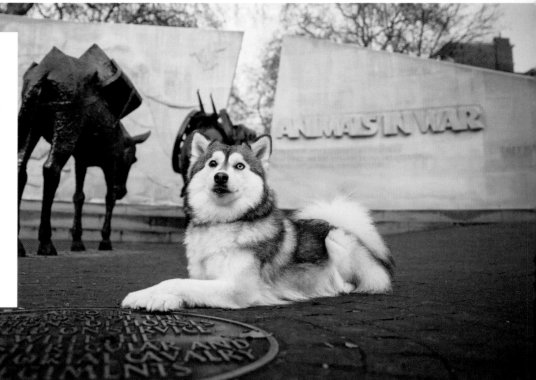

DUTCH
Pomsky

Animals in War Memorial, Hyde Park

Dutch is a pomeranian-husky cross and a registered emotional support animal. Nothing gets past her—she is extremely intelligent. She already knows forty-eight tricks, and counting. This one was easy: smile for the camera.

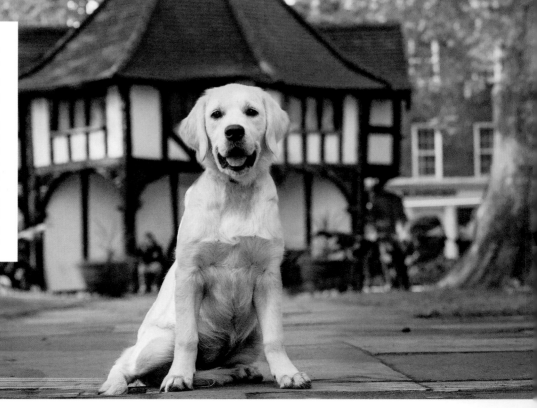

ANGEL
Golden Retriever
Soho Square

@goldenretrievers8

Angel is pictured here in a rare moment alone. She is a bit of a scaredy-cat—feather dusters are particularly alarming—and she likes to hide behind her doggie friends, Love and Music.

MAPLE
Toy Poodle
Primrose Hill
@maple_toypoodle

Maple is a powerful package of pure joy! She's proud of her beautiful coat and doesn't mind being groomed. But she pays her humans back in kind by scratching their heads and playing with their hair. Fair's fair.

WUFFA
Woodle

Chancery Lane

Wuffa (formal name Mr. Wuffles) was found abandoned on Christmas Eve, along with his two sisters. He was the runt of the litter, but fought his way back from serious illness and dehydration to good health. He shares his name with the first Anglo Saxon king, King Wuffa, whose name meant "little wolf"—an appropriate moniker for this feisty and resilient little chap.

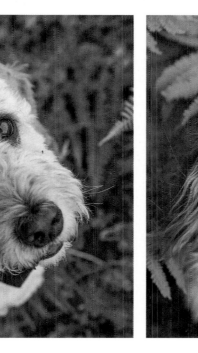

BAILEY

Labradoodle

Richmond Park

JAKE

Cavalier King Charles Spaniel

Richmond Park

VESPA

Border Collie

Victoria & Albert Museum

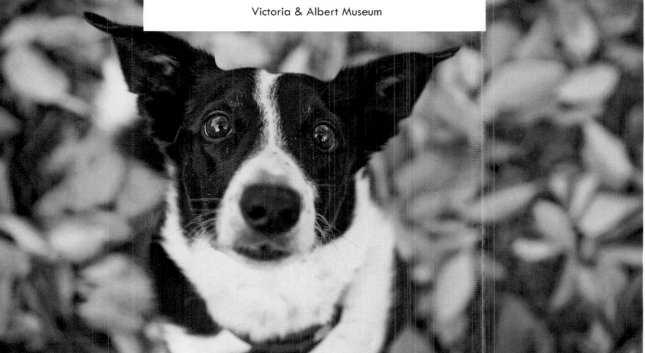

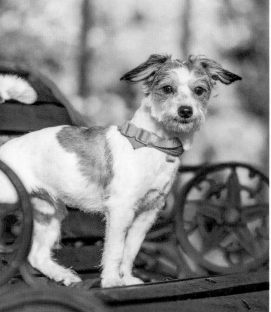

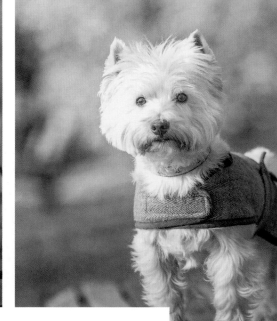

KYLO

Jack Russell Mix

Battersea Park

BUMBLE

West Highland White Terrier

Primrose Hill

BUTCH

Bulldog

Primrose Hill

FRANK

Miniature Dachshund

Whitehall Gardens

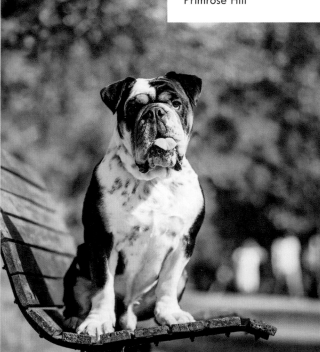

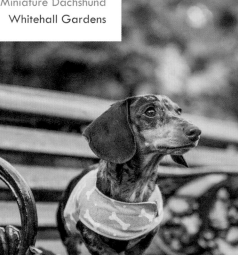

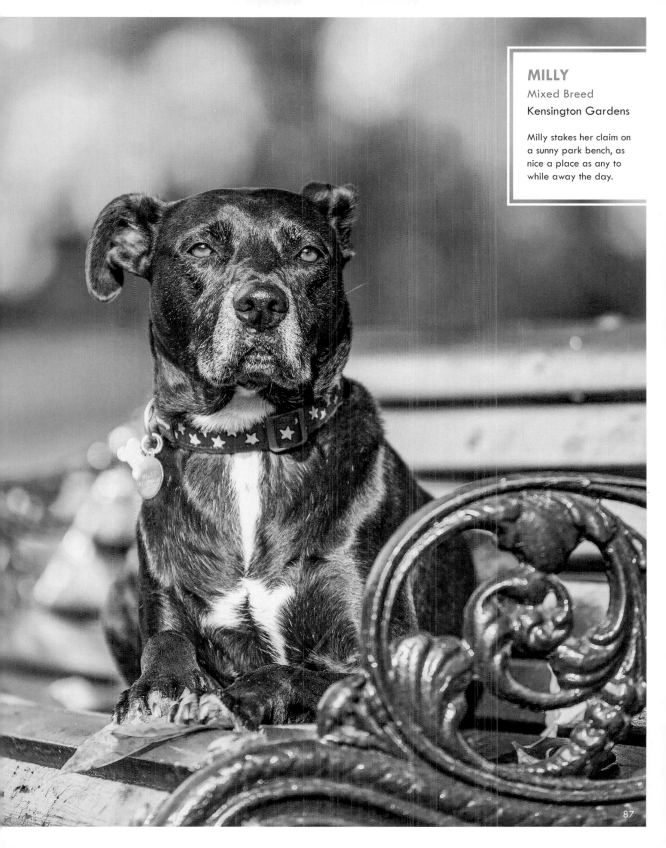

MILLY
Mixed Breed
Kensington Gardens

Milly stakes her claim on a sunny park bench, as nice a place as any to while away the day.

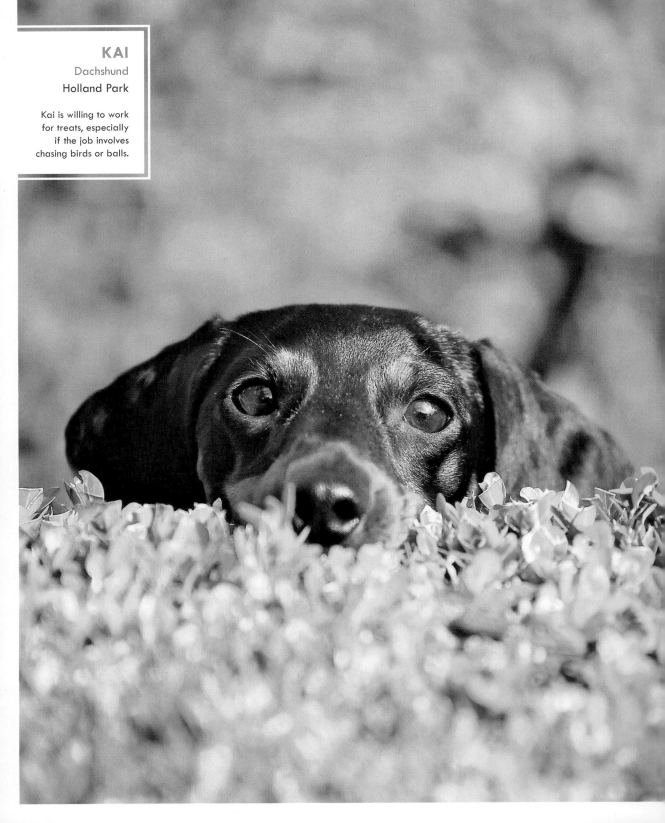

KAI
Dachshund
Holland Park

Kai is willing to work
for treats, especially
if the job involves
chasing birds or balls.

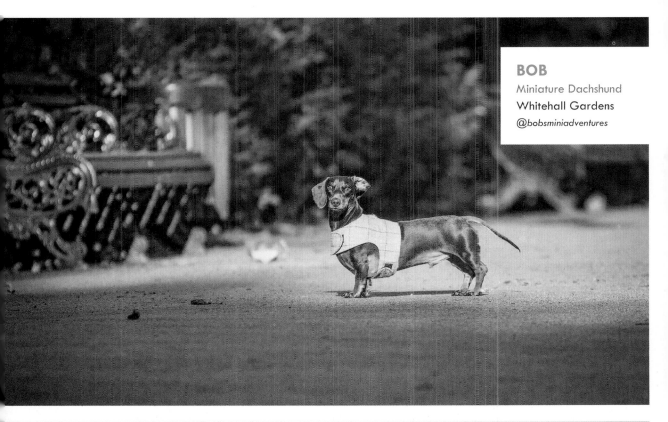

BOB
Miniature Dachshund
Whitehall Gardens
@bobsminiadventures

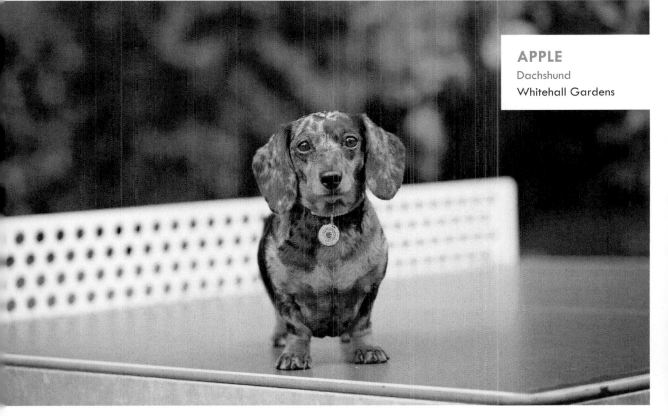

APPLE
Dachshund
Whitehall Gardens

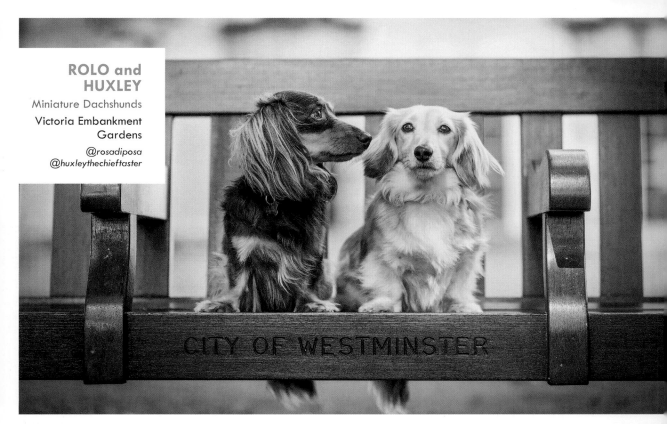

ROLO and HUXLEY

Miniature Dachshunds

Victoria Embankment Gardens

@rosadiposa
@huxleythechieftaster

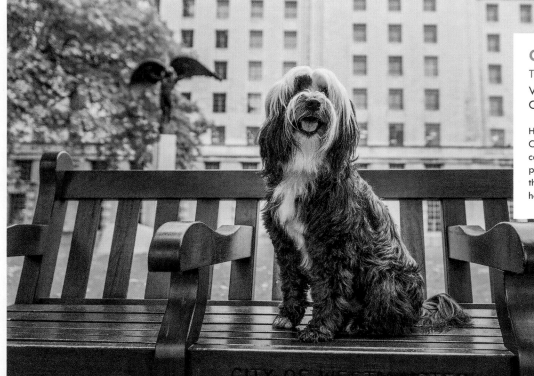

CHINO

Tibetan Terrier

Victoria Embankment Gardens

He's a stubborn fellow. Cheeky, but lots of fun. You can tell by the way he sits proudly on this park bench that he's the ruler of the house—and everyone's heart.

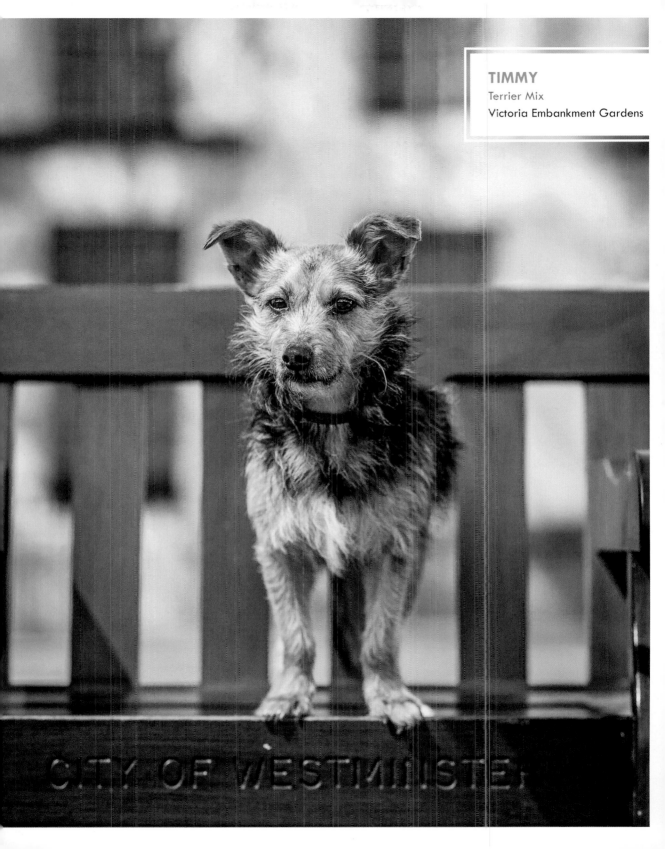

TIMMY
Terrier Mix
Victoria Embankment Gardens

DAISY
Shorkie

Hampstead Heath

Daisy is so adorable and calm that even children who are afraid of dogs fall in love after a few minutes with her. She is a registered Pets as Therapy volunteer dog, so it's just all in a day's work for her.

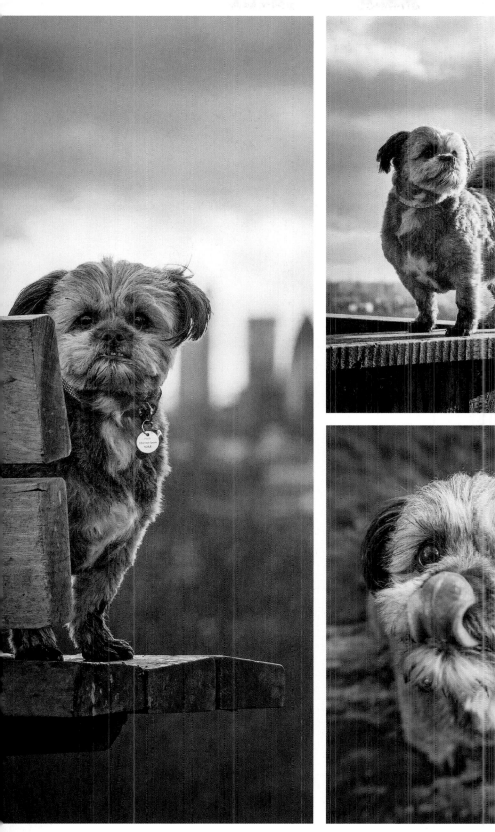
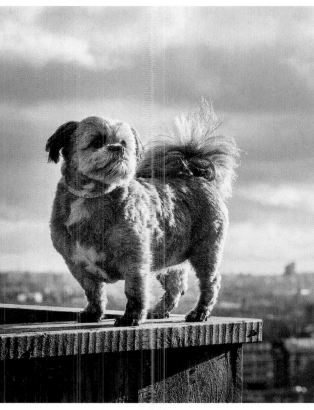

LONDON
The Thames

And dream of London, small and white and clean,
The clear Thames bordered by its gardens green.

—William Morris

GERTIE

Schnauzer

South Bank at Low Tide

Gertie doesn't like getting wet, but she loves strolling along the Thames on a sunny day where she can enjoy the scene from the safety of a high, dry embankment.

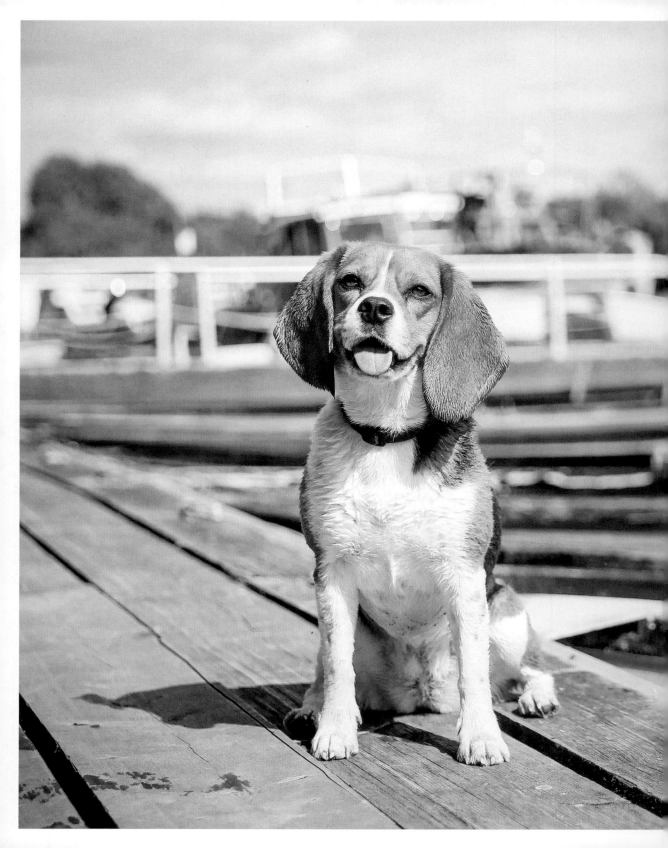

ELI'Z
Beagle
Richmond

Once upon a time, a little beagle was born in France. Then she moved to England and later Hong Kong, China. When back in London, she likes to stop at her "happy place"—along the river in Richmond. Elizabeth may head to a favorite picnic spot in nearby Bushy Park next.

FREDDIE
Mixed Breed
Albert Bridge

You won't find Freddie barking up the wrong bridge. This beautiful London resident is a rescue dog from Battersea Dogs Home and knows her way around the streets.

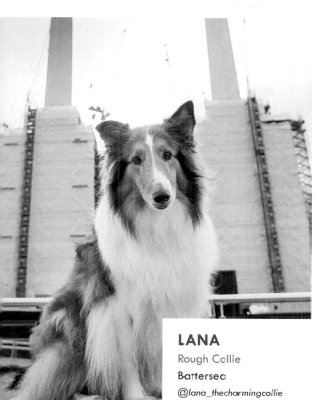

LANA
Rough Collie
Battersea
@lana_thecharmingcollie

AMBER
Vizsla
Golden Jubilee Bridge

SIDRO
Mixed Breed
Blackfriars Railway Bridge

KHEL
German Shepherd
Chelsea Bridge
@Khelsroopleahlily

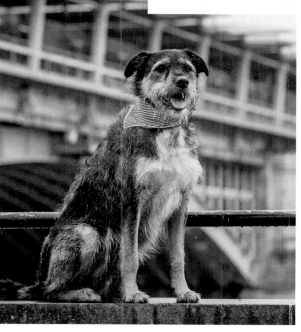

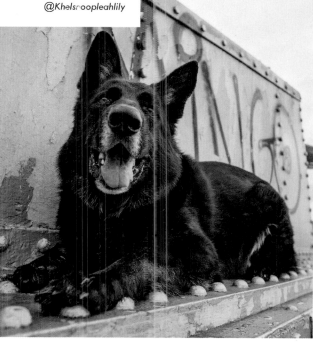

ZEUS

Alaskan Malamute

Hungerford Bridge

@london_malamute

Zeus is a two-year-old Alaskan malamute rescued from Vietnam. As soon as his owner came across him, he just couldn't leave him behind! At the time, he was just a small, fluffy dog who was most definitely too young to be away from his mother, and out of his depth trying to be a snowdog in the hot tropics of Vietnam. He's now living his best life as a full-time office dog and part-time tourist attraction in Central London.

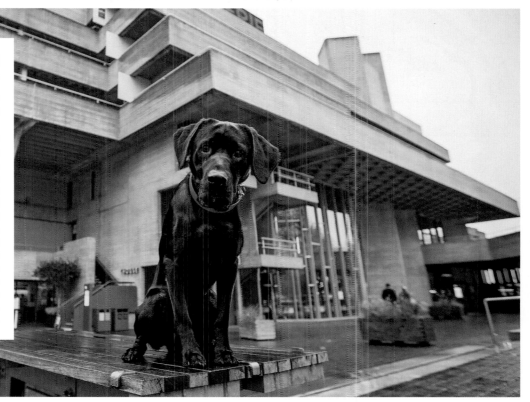

BRUCE WAYNE
Labrador
The National Theatre
@brucewaynemcnaught

Bruce Wayne loves to climb on the chairs at home in Sidcup, southeast London. When out on the town, however, he chooses a bench outside the National Theatre. With a face this dark and handsome, he thinks he could be an actor himself one day. He was secretly hoping to be the next Batman, but he heard Robert Pattinson got the part. Oh, well. He can still pretend.

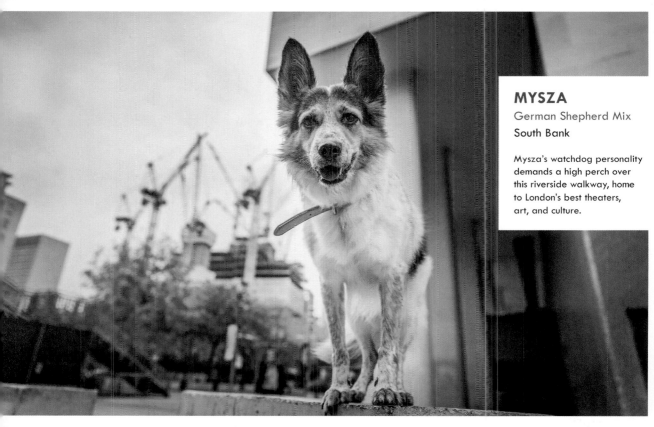

MYSZA
German Shepherd Mix
South Bank

Mysza's watchdog personality demands a high perch over this riverside walkway, home to London's best theaters, art, and culture.

FRANK

Miniature
Dachshund

South Bank

@bobsminiadventures

Frank is always on the
hunt for a little drama
(some would call it
trouble!) and there's
no better place to
look for it than this skate
park near the Thames.
The bright colors of
the graffitti make the
perfect backdrop for
this little guy.

CHARLEY
Terrier Mix
South Bank

Mayhew Rescue Dog

This thirteen-year-old little lady still knows how to get cuddles and steal hearts. As a rescue dog, she's proud of her origins, and always happy to see where life will take her.

KAI
Dachshund
South Bank

Well-mannered and
well-trained Kai can hold
a pose like a pro. His
dark, glossy coat and
handsome red collar are
the perfect match for this
colorful wall behind him.
When released from his
position, he likes to bolt
and bark at birds.

MAGGIE
Beagle
Thames Tide Line

A proud transplant
from the USA, Maggie
happily works part time
in her human's shop.
When she has free
time, it's straight to
the water's edge.

GERTIE
Schnauzer

Thames Beach at Low Tide

This schnauzer knows how to have a good time, whether she's chasing frozen peas around the kitchen floor at home or catching a ball on the beach. When it's low tide along the Thames, there's no chance she'll get wet. (Gertie thinks water must always be avoided!)

PERCY
Cockapoo
City Hall
@percyythecockapoo

Percy is a registered therapy dog, always ready to dispense cuddles and care. He can stand happily like a statue in the middle of a busy city while having his photo taken, even when the wind is whipping around the elegant curve of London's City Hall. Yet he's also a little ball of energy who's up for any adventure.

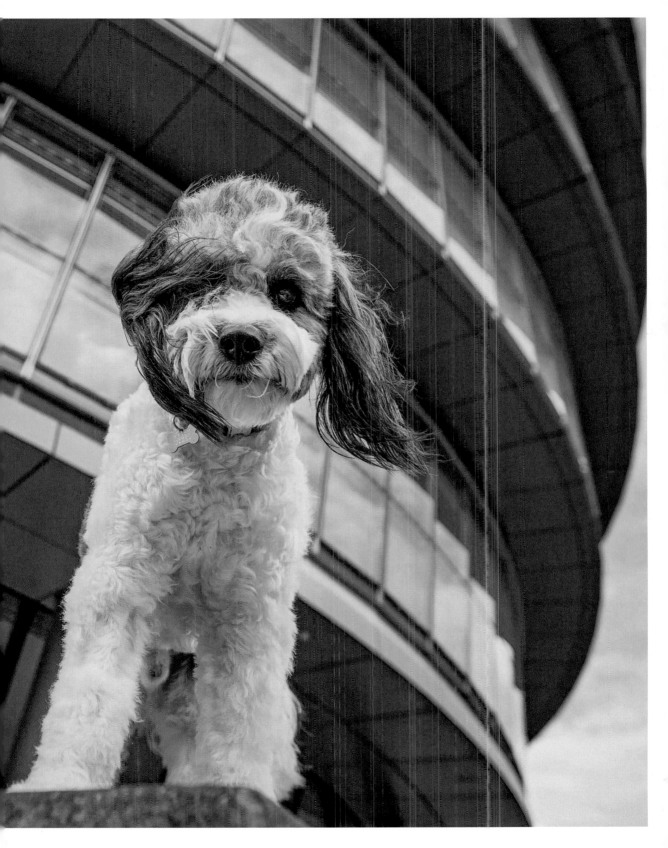

BENTLEY
Bulldog
The City of London
@Bentley_the.bully

Bentley stands his ground against a backdrop of The City of London, the country's busy financial district and home to the Bank of England. Modern skyscrapers don't phase this placid guy one bit.

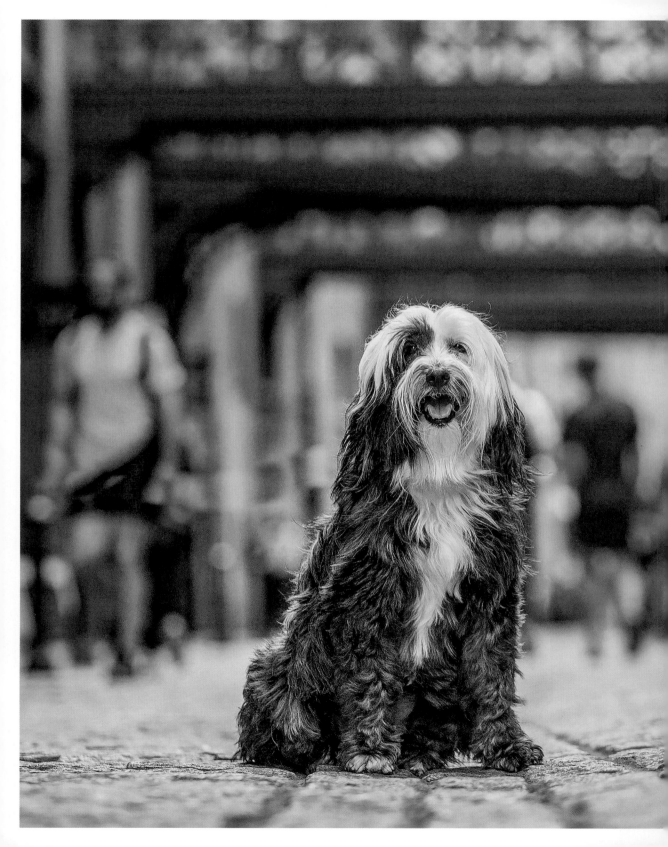

CHINO
Tibetan Terrier
Butlers Wharf
@michelle_and_chino

This mischievous fellow looks like the picture of decorum, but, as the self-appointed guardian of the street, he may suddenly give chase to a passing jogger. And fair warning: he's an ardent vegetable lover who would likely mug you for a piece of broccoli.

MAYA
Yorkshire Terrier
St. Katherine's Dock
@mayachanlondon

Bright-eyed little Maya
is an energetic companion
who's always on the alert
for a good time.

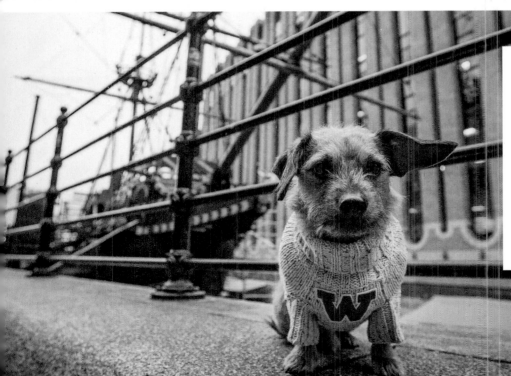

BENTLEY
Bulldog
St. Katherine's Dock
@Bentley_the.bully

Don't let the wrinkles on his face fool you. Bentley doesn't have a care in the world today as he spends the afternoon just downstream from the Tower of London

WAYNE
Miniature Dachshund–
Jack Russell Mix
The Golden Hinde
@wayne.n.garth

Wayne, wearing his letter sweater, is a good traveler. He has also visited Paris and Barcelona, but the truth is he likes staying home the best—snuggled up with his humans and his beloved brother, Garth.

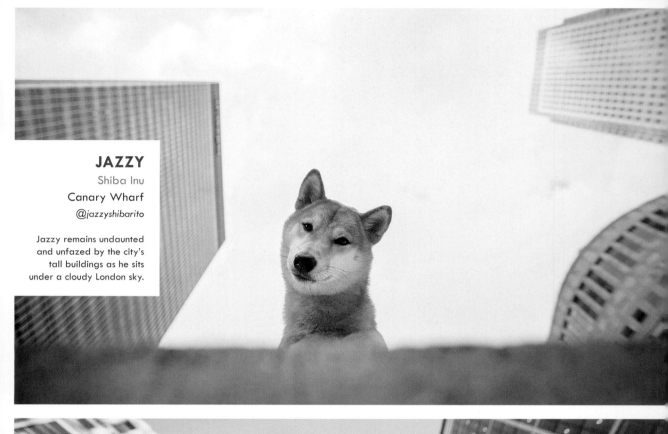

JAZZY
Shiba Inu
Canary Wharf
@jazzyshibarito

Jazzy remains undaunted and unfazed by the city's tall buildings as he sits under a cloudy London sky.

COLIN
Miniature Schnauzer
Canary Wharf
@littlecolinschnauzer

Colin hails from East London and is happiest when he's the center of attention—as he makes clear in this photo.

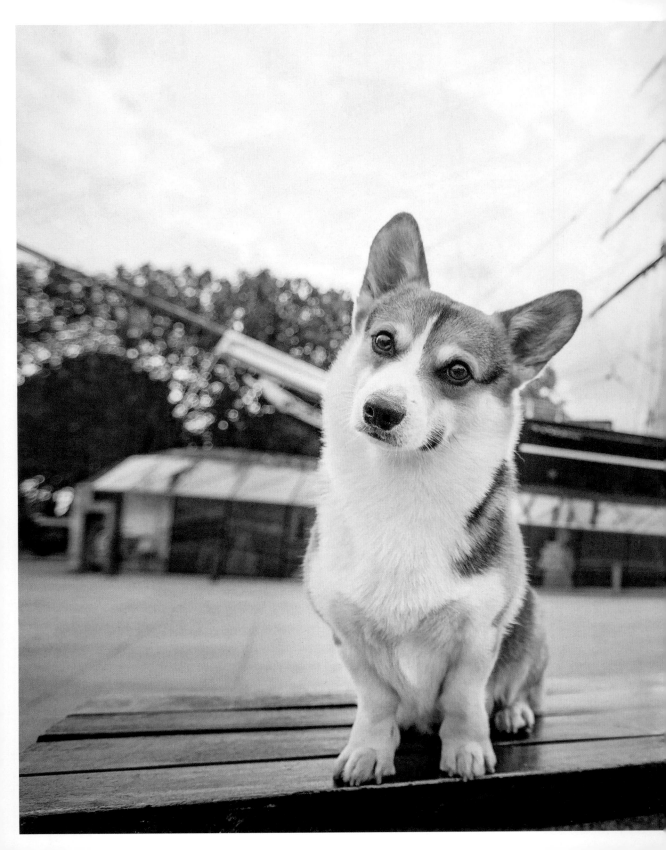

MORTY
Pembroke Welsh
Corgi
The Cutty Sark
@morty_thetricorgi

Tilted head, sparkling
eyes, and a shy smile—
Morty is a cutie. If you
want to know what he is
thinking about here, his
human says he is always
thinking about food. The
150-year old clipper
ship behind him is of little
interest ... unless they're
serving dinner onboard.

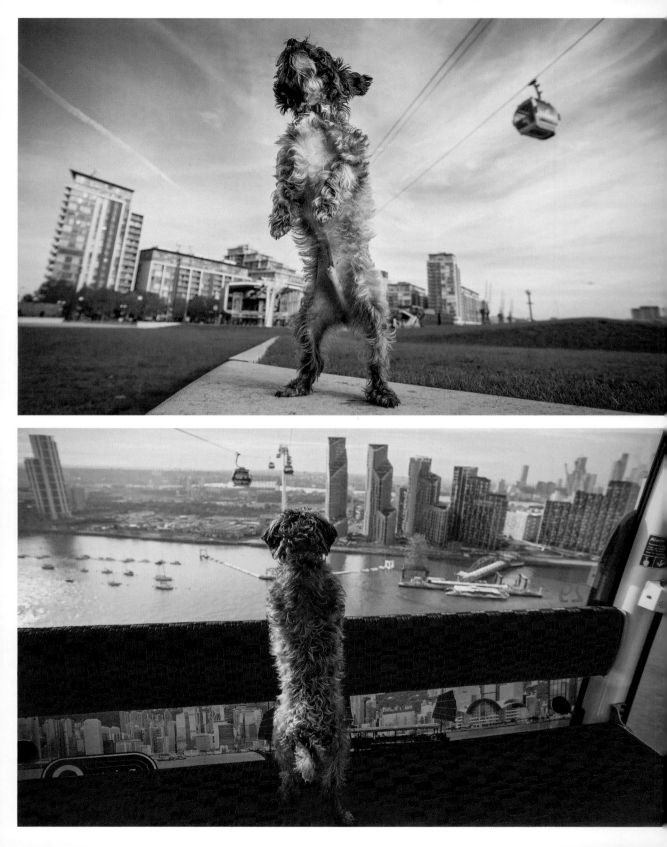

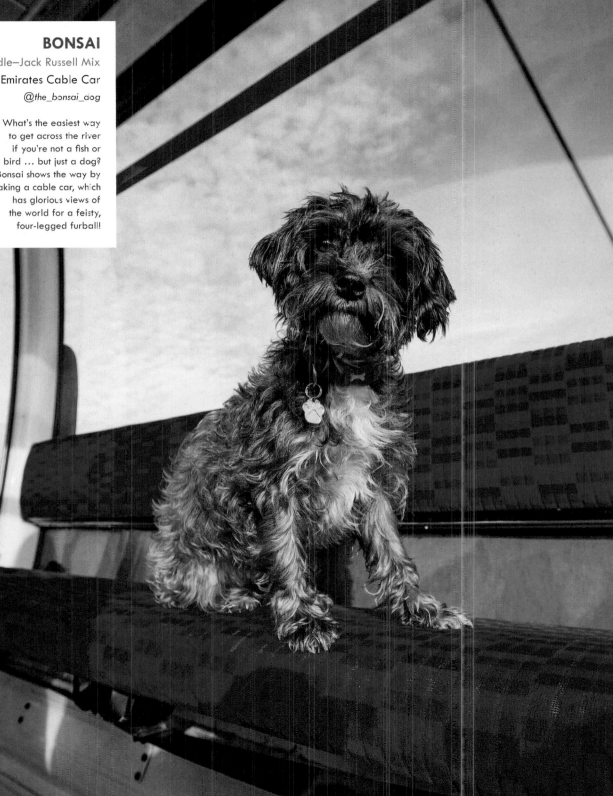

BONSAI

Poodle—Jack Russell Mix

Emirates Cable Car

@the_bonsai_dog

What's the easiest way to get across the river if you're not a fish or a bird ... but just a dog? Bonsai shows the way by taking a cable car, which has glorious views of the world for a feisty, four-legged furball!

LONDON
Neighborhoods

I've been walking about London for the last thirty
years, and I find something fresh in it every day.

—Walter Besant

MARNIE

Cavalier King Charles
Spaniel

Tate Britain

@cavdashians

Marnie was rehomed when
she was two and happily
reunited with her twin, Tilly.
Marnie is so cuddly and
loving that she has become
a therapy dog. People feel
instantly comforted by her
sweet face and long silky fur.

CHURCHILL

Miniature
Dachshund

The East End

While Churchill is a
country dog at heart,
he's more than happy
to visit London's up-
and-coming East End—
as long as he has
a dignified perch
from which to survey
the passersby.

DOM
Border Collie
Fitzrovia
@bordercolliedom

Ah! The sights and smells of the restaurants, historic pubs, and bars in this lively neighborhood always make Dom's mouth water.

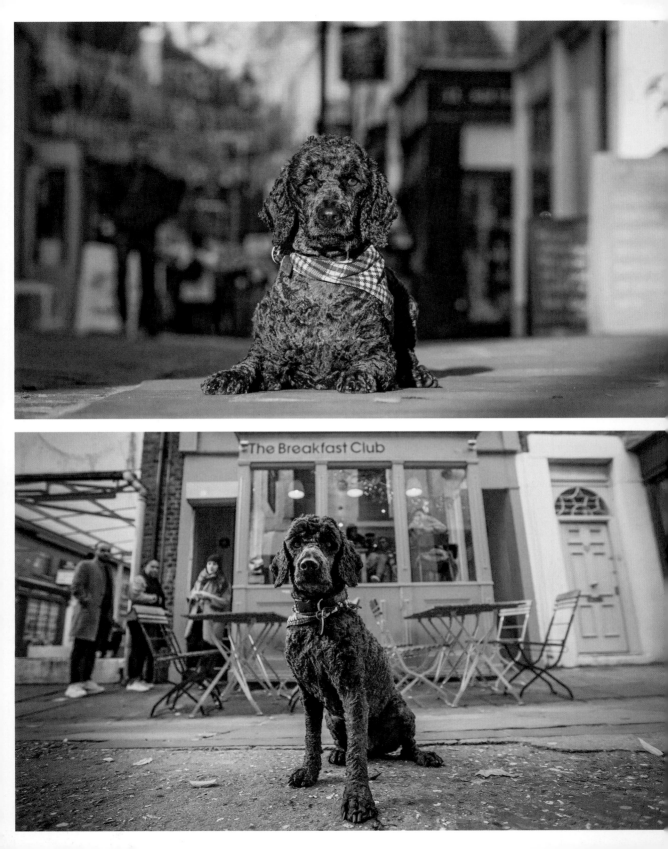

LONDON BOROUGH OF ISLINGTON

CAMDEN PASSAGE N.I

MILTON
Cockapoo
Camden Passage

Milton used to work in accounts receivable at a bookshop. These days, however, he is self-employed and happy to be his own dog. He is often seen sporting a jaunty red bandana, waiting to board the 5:31 Euston-Glasgow train for his frequent business trips.

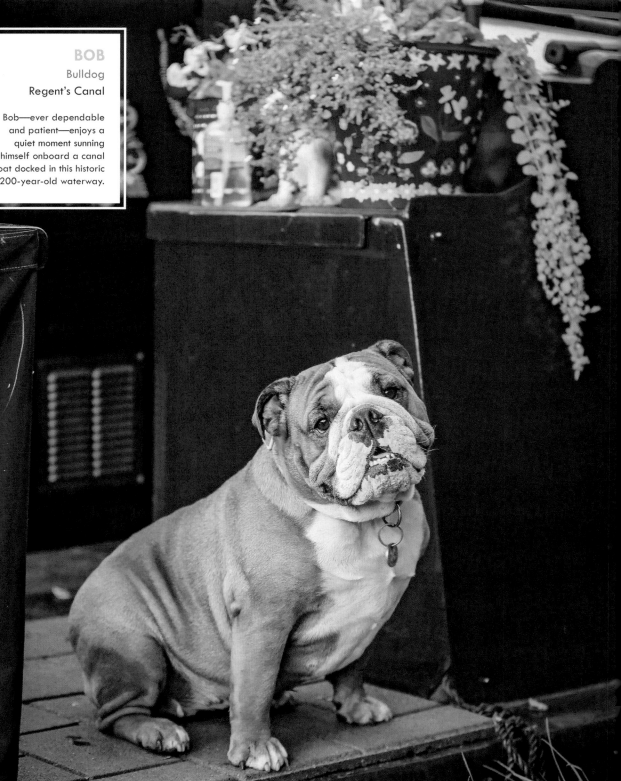

BOB
Bulldog
Regent's Canal

Bob—ever dependable and patient—enjoys a quiet moment sunning himself onboard a canal boat docked in this historic 200-year-old waterway.

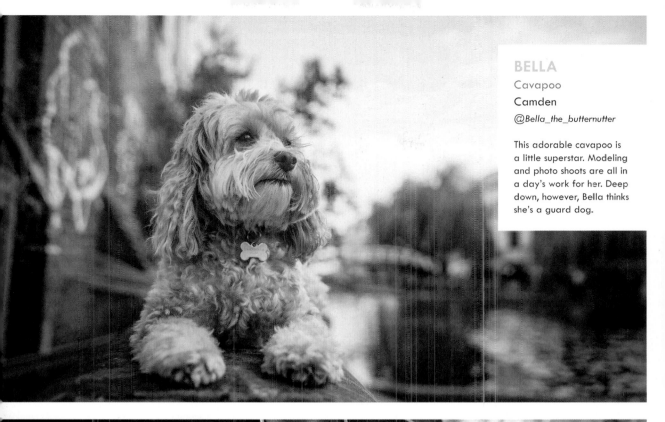

BELLA
Cavapoo
Camden
@Bella_the_butternutter

This adorable cavapoo is a little superstar. Modeling and photo shoots are all in a day's work for her. Deep down, however, Bella thinks she's a guard dog.

NIGEL
Staffordshire Bull Terrier
Regent's Canal

A houseboat is the perfect spot for a courageous and curious dog with dreams of big adventures. Nigel is ready to go whenever you are.

DOUGH
Jack Russell Terrier
Little Venice

With a pet passport and willing to travel, cheeky, friendly Dough is pictured here *en plein air* during a visit to London from his native France. Say cheese!

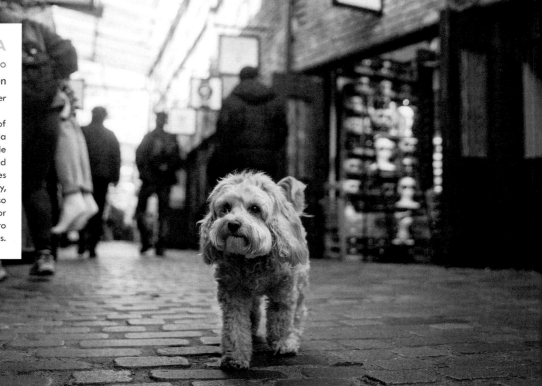

BELLA
Cavapoo
Camden
@Bella_the_butternutter

Strolling the streets of Camden Town, Bella is in search of a little shopping, but has decided the goth and punk styles are not for her. Luckily, this neighborhood is also the perfect spot for vintage gear and retro style fashions.

BUGSY
Coton de Tulear
Camden
@Two_little_bugs_

Bugsy is not just another pretty face. You don't have to tell him anything twice. He is super intelligent, surpassing many of his two-legged friends.

BROCCOLI
Mixed Breed
Camden
#broccolithemongrel

This awesome crossbreed fits right in to the eclectic scene at Camden Market. The music! The art! The food! Broccoli is here to take it all in.

WUFFA
Woodle
Chancery Lane

Always eager to please, this pretty poodle and Welsh terrier mix poses in front of a classic stone archway in one of London's oldest neighborhoods.

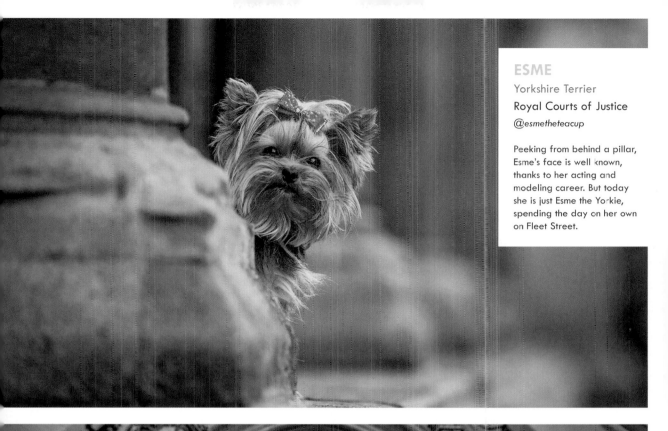

ESME
Yorkshire Terrier
Royal Courts of Justice
@esmetheteacup

Peeking from behind a pillar, Esme's face is well known, thanks to her acting and modeling career. But today she is just Esme the Yorkie, spending the day on her own on Fleet Street.

WHISKY
Pembroke Welsh Corgi
Royal Courts of Justice

Whisky stands as tall as she can outside the impressive doors of London's High Court and Court of Appeal of England. She stands for all things true and just.

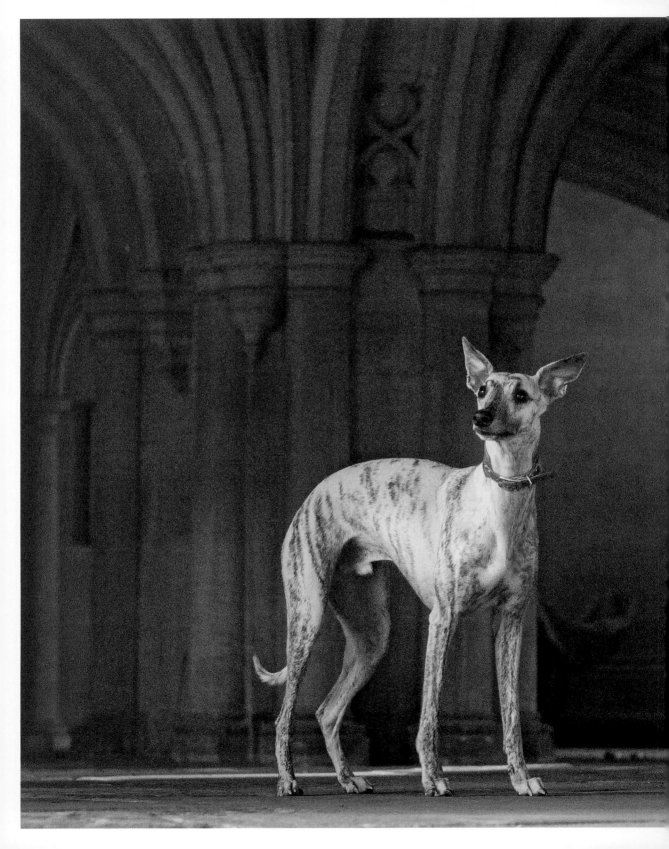

ROLO
Whippet
Lincoln's Inn Fields
#Rolostaceyhunt

Rolo is often seen around town dressed in his own personalized wardrobe, including a fabulous dinosaur outfit which has earned him the nickname Dino Dog. He flat-out refuses to walk if he's cold. Today is warm enough for him to go *au naturel*, however.

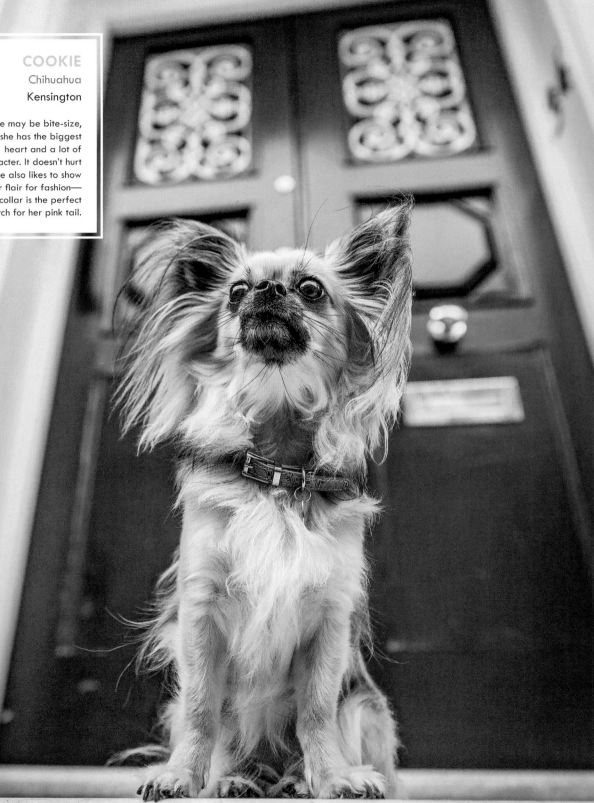

COOKIE
Chihuahua
Kensington

Cookie may be bite-size, but she has the biggest heart and a lot of character. It doesn't hurt that she also likes to show off her flair for fashion— her pink collar is the perfect match for her pink tail.

LILY
Shetland Sheepdog

Alice's, Notting Hill

CONCHITA
Miniature Dachshund

Prircess Mews

@conchita_sass_qween

WATSON
Cocker Spaniel–
Daschund Mix

Baker Street

SHARKY
Whippet

Queen Anne's Gate

@sharkythewhippet

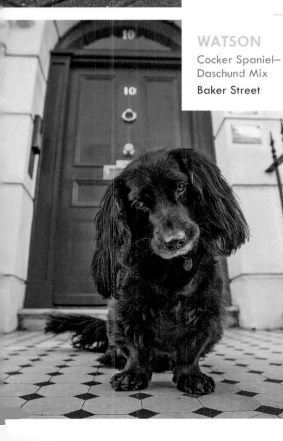

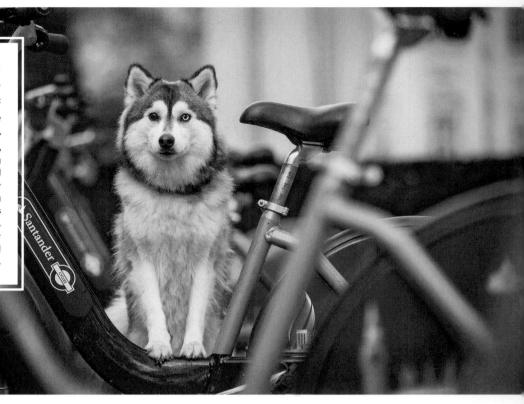

DUTCH
Pomsky
Duke of Wellington Place

@dutch_thepomsky
Biking is nice for humans, but Dutch prefers long woodland walks and playdates with her pomsky friends. She's an easy-going gal, as long as her humans are not late with her dinner. And please don't try to serve her mushrooms! She can't stand them.

DAPHNE
Chiweenie
Picadilly Circus

@daphnethewondersossige

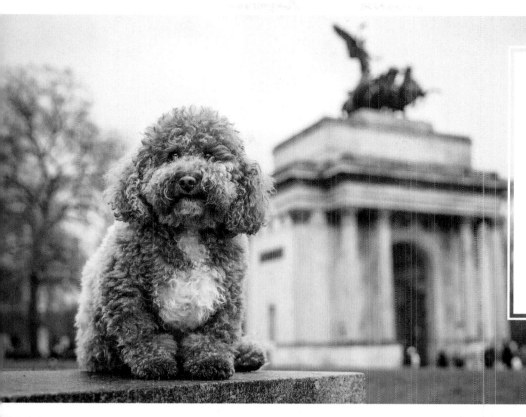

HENRY

Toy Poodle–Bichon Frise Mix

Wellington Arch

Battersea Rescue Dog

After a tough start in life, Henry ended up at Battersea Dogs & Cats Home. When his owners found him, he lacked energy and confidence and didn't even want to play with toys. What a difference a good home makes! Henry is now full of life and loves to play.

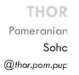

THOR

Pomeranian

Soho

@thor.pom.pup

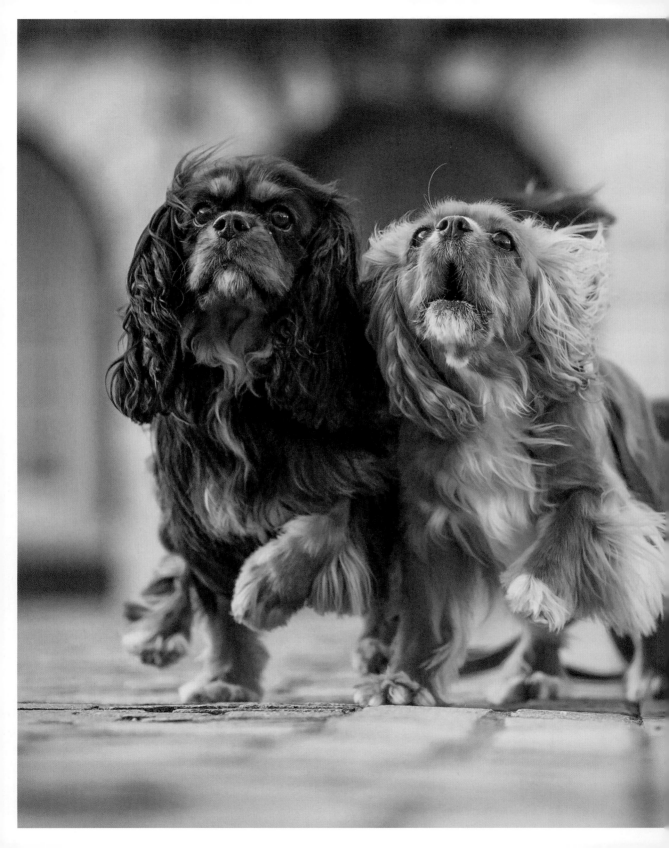

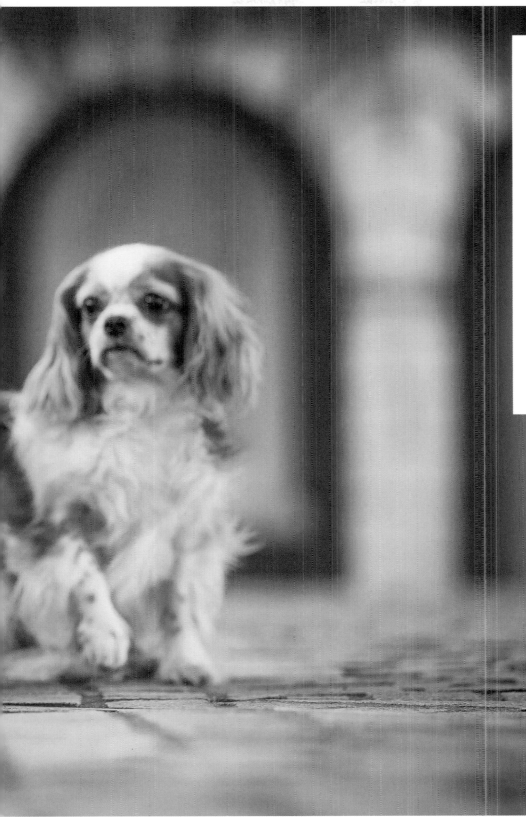

THE CAVDASHIANS

Cavalier King
Charles Spaniels

Tate Britain

@cavdashians

Tilly (black-tan), Marnie
(ruby), and Maddie
(Blenheim) are an
adventurous trio: the
three cavaliers. Tilly and
Marnie are littermates
who were reunited when
Marnie was rehomed at
the age of two. Maddie
was rescued from a
puppy mill. Together,
they are known on
social media as the
"Cavdashians." Although
they had a rough start in
life, they are now some of
the friendliest, happiest,
and most outdoing dogs
in London.

DAPHNE
Chiweenie
Peggy Porschen, Chelsea
@daphnethewondersossige

Daphne is looking pretty in pink, as always, while she waits at a café. She is used to being surrounded by the bright lights of London and gets lots of attention thanks to her modeling career.

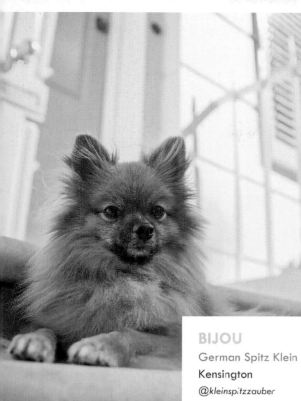

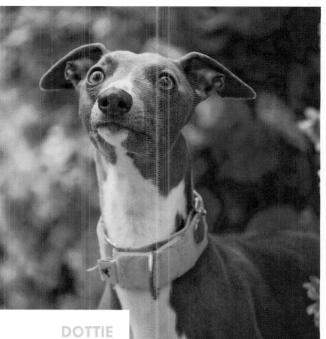

BIJOU
German Spitz Klein
Kensington
@kleinspitzzauber

DOTTIE
Whippet
Belgravia
@country_and_twee

SYDNEY
Mi-Ki
Chelsea
@little_sydney_miki_pup

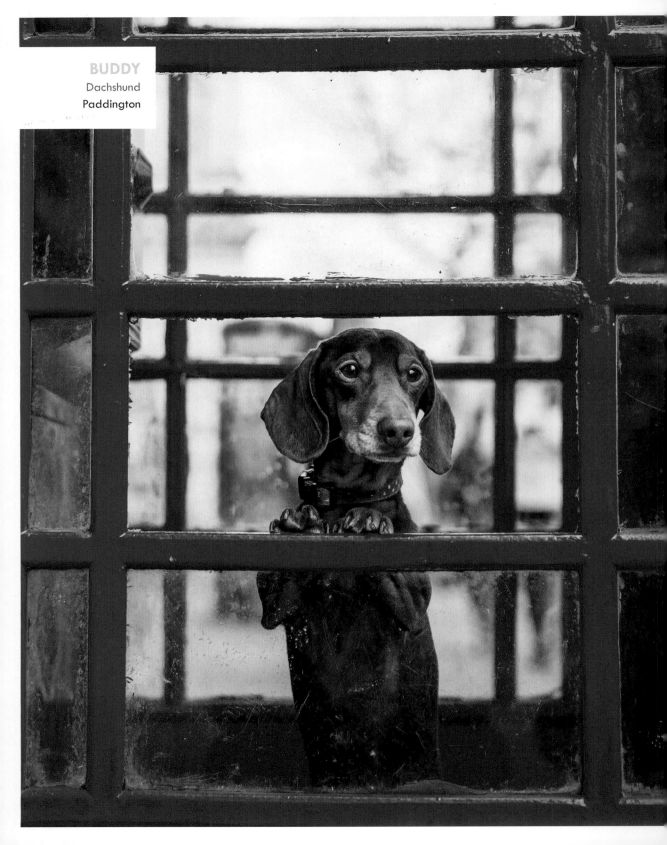

BUDDY
Dachshund
Paddington

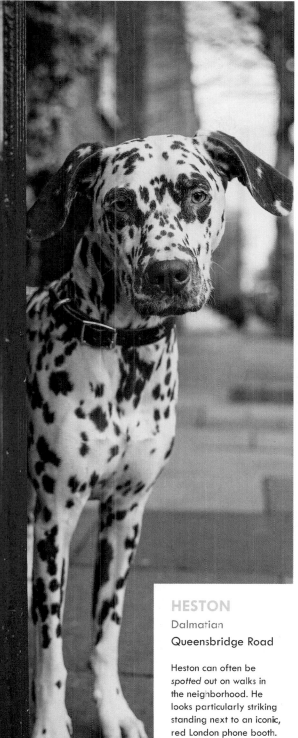

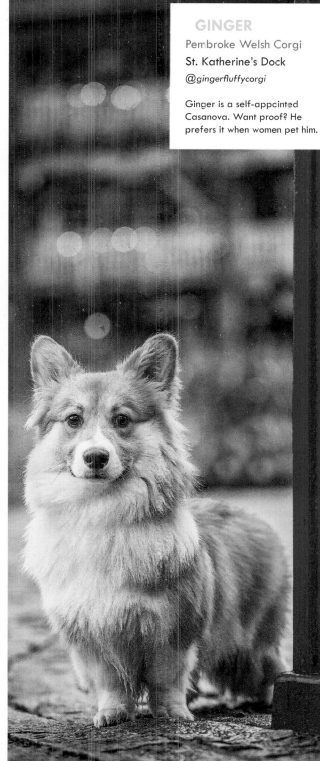

GINGER

Pembroke Welsh Corgi

St. Katherine's Dock

@gingerfluffycorgi

Ginger is a self-appointed Casanova. Want proof? He prefers it when women pet him.

HESTON

Dalmatian

Queensbridge Road

Heston can often be *spotted* out on walks in the neighborhood. He looks particularly striking standing next to an iconic, red London phone booth.

CLAUDE
Golden Retriever
Picadilly Arcade
@the_life_of_claude_and_elmo

This handsome boy likes to celebrate the holiday season by wearing his cheerful, red bow tie. This year, like every year, he has asked Santa for more cuddly toys. Too many is never enough— he has been known to put up to twelve in his mouth at once.

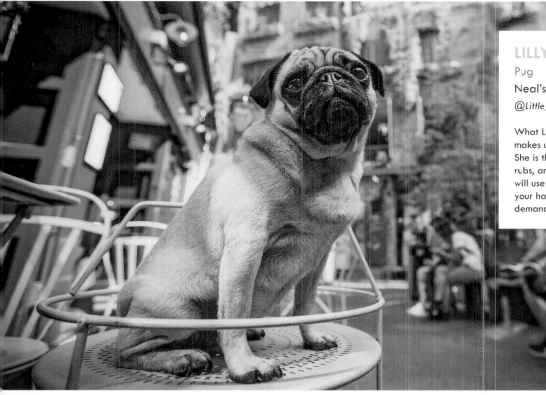

LILLY
Pug
Neal's Yard
@Little_lil_pug

What Lilly lacks in size she makes up for in personality. She is the queen of belly rubs, and if you stop, she will use her paw to push your hand back and demand more.

CHEWIE
Shih Tzu
Burlington Arcade
@chewiesawookie

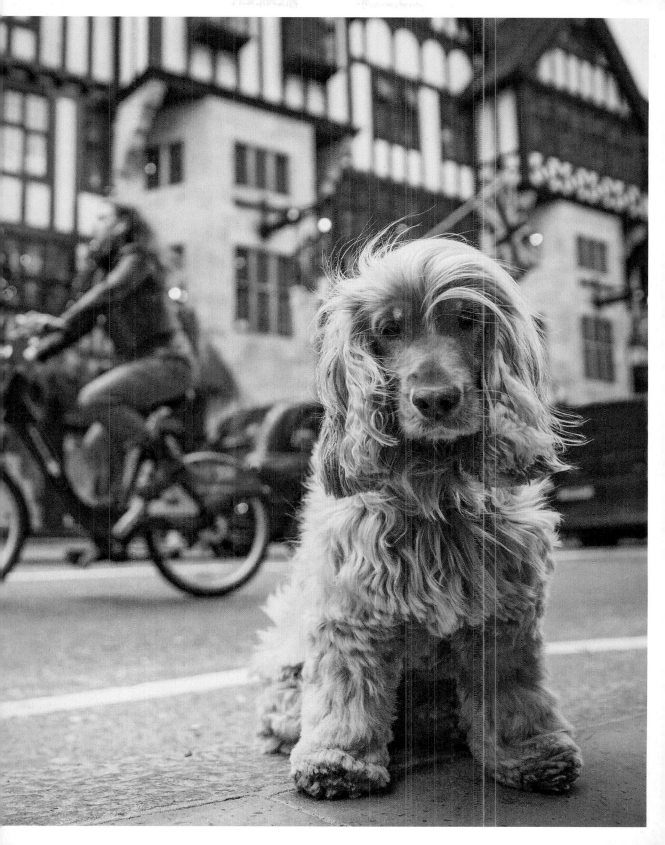

BARNEY
Dachshund
The Egerton House Hotel
@barneys_adventure

What could be better for a dapper doxie like Barney than to step out for afternoon tea at the pet-friendly Egerton House in Knightsbridge. His friends know him as a seasoned model, bow tie wearer, fashionista, and all-around cool dude.

SAFFY
Cavapoo

Bathurst Mews

@saffyinlondon

Saffy is a proud Londoner with a bouncy, outgoing personality. She can leap into the air like Tigger and loves to chase city squirrels, but is often found barking up the wrong tree. She's happy riding the London buses back home, as long as she's not on the floor and can see out the window.

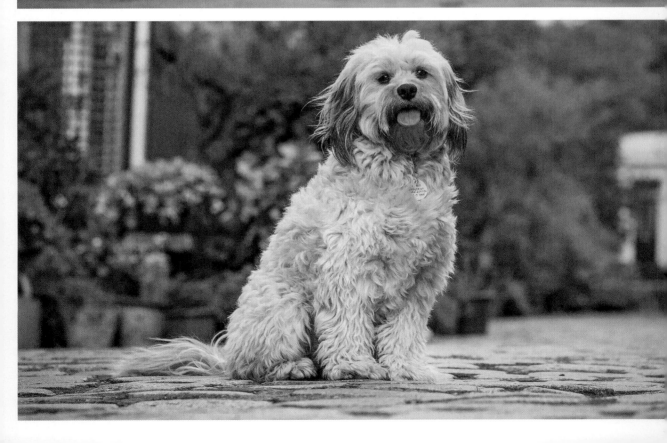

MADDIE
Cavalier King Charles Spaniel
Chelsea College of Art
@cavdashians

Maddie lives with Tilly and Marnie. Maddie joined her new family in 2018, after being rescued from a puppy farm by the charity Many Tears. When she arrived, she was very thin, had no fur, and was timid and scared of people. She has since put on weight and grown a beautiful, long coat and tail. She is now a fun-loving, playful dog who is enjoying life to the fullest. The threesome, known on social media as the "Cavdashians," have a jam-packed social calendar, full of doggie events, parties, meet-ups, and group walks.

MABEL
Cockapoo
Sherlock Holmes Museum
@mabel_the_cockapoo

This fluffy, little girl with her multicolor fur puts a smile on everyone's face. Just ten months old, she is already a veteran treat connoisseur.

WATSON

Cocker Spaniel–
Dachshund Mix

Baker Street

He's a long way from his
original place of birth
in Cyprus, where he
was found abandoned
along the road as a
puppy. Now, London
is Watson's adopted
home, and he is happy
to be photographed
investigating what's
happening on Baker
Street, the fictional
address of the famous
sleuth Sherlock Holmes.

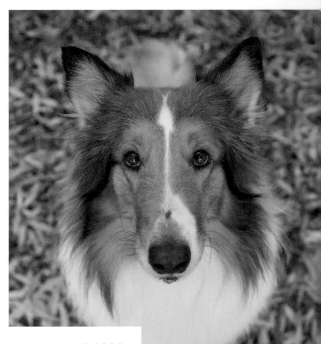

SPARX
Mixed Breed
The British Library

LANA
Rough Collie
Battersea

BESSIE
Mixed Breed
Battersea Park

FRANK
Puggle
John Smith Square

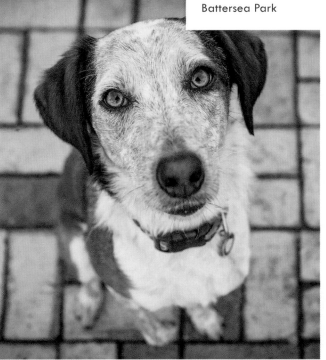

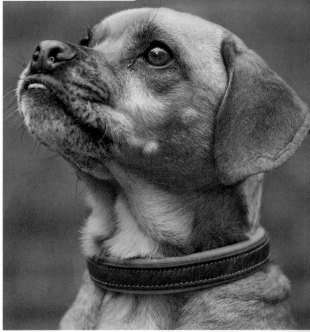

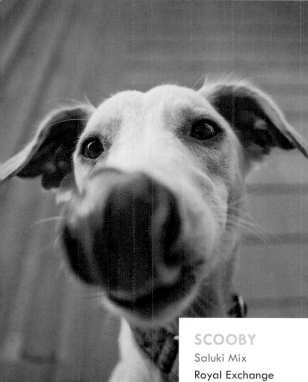

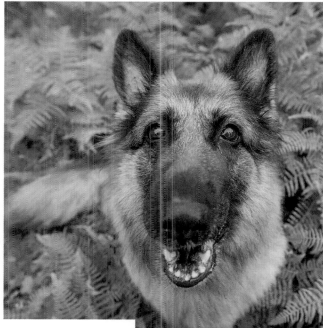

SCOOBY

Saluki Mix

Royal Exchange

GEORGIE

German Shepherd

Richmond Park

LYCHEE

Cockapoo

Lovat Lane

HESTON

Dalmatian

Columbia Road

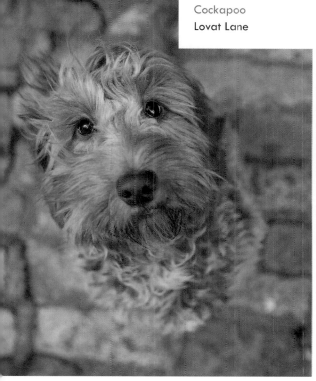

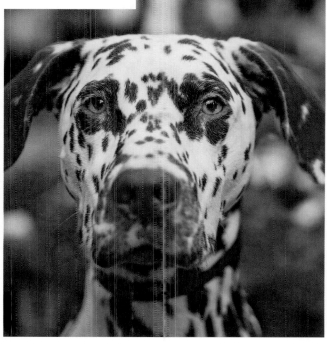

STAN
Dachshund

Paddington Station

Stan loves the camera. Even in the middle of Paddington Station, he can keep his eye on the camera and is the perfect model. He doesn't know why he hasn't made the cover of *Vogue* yet.

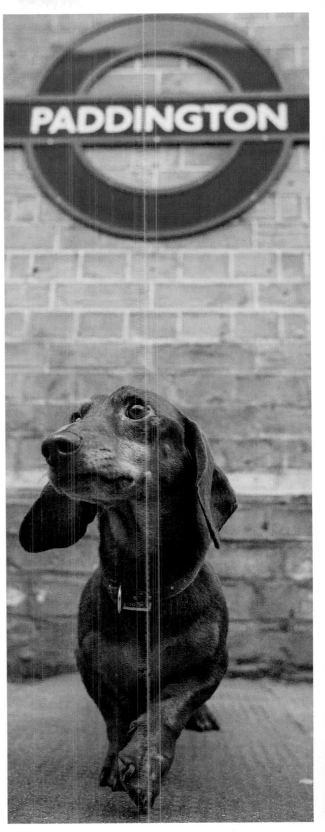

QUINN

Shetland Sheepdog

James Smith & Sons Umbrellas

@savendieshelties

Quinn is the eternal optimist. She loves sunny days, but can see the bright side of a rainy one as well. Surrounded by a collection of colorful umbrellas, she thinks her humans should be prepared to take her out in all kinds of weather. The James Smith & Sons store on New Oxford Street is largely unaltered, since it was built in the 19th century. This London landmark is commonly referred to as "The Umbrella Shop" by black cab drivers and locals alike.

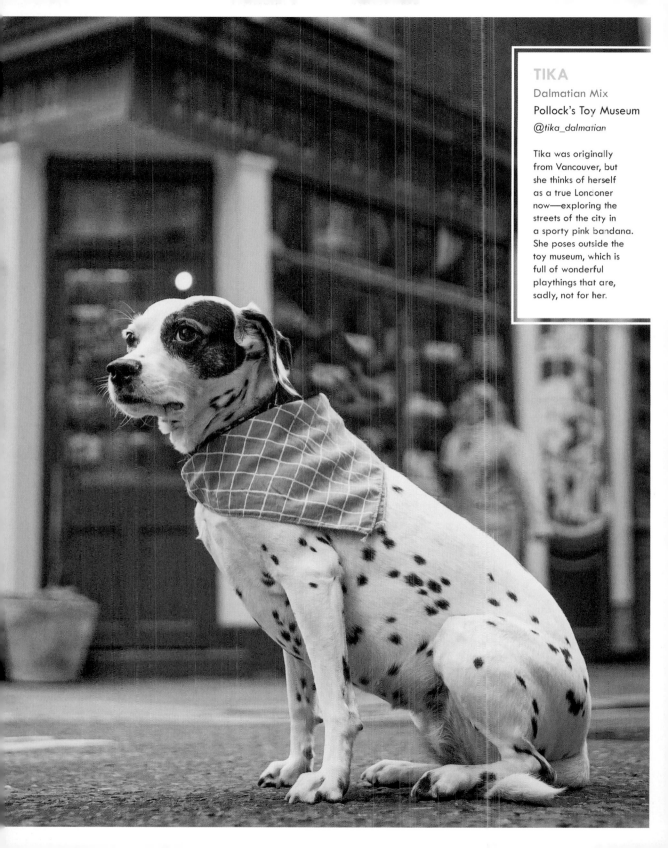

TIKA

Dalmatian Mix

Pollock's Toy Museum

@tika_dalmatian

Tika was originally
from Vancouver, but
she thinks of herself
as a true Londoner
now—exploring the
streets of the city in
a sporty pink bandana.
She poses outside the
toy museum, which is
full of wonderful
playthings that are,
sadly, not for her.

ARGO
Mixed Breed

Pavilion Road, Chelsea
@thelondog

Argo was called "Little Bear" by the shelter before he joined his foster family. Once he found his forever family, he grew and grew from a tiny pup to a much larger size befitting his nickname. He's pictured here on city streets, but when near the water he fancies himself a lifeguard and barks at the swimmers.

SHILOH and SAVANNA

Spaniel Mixes

Leadenhall Market

@mutts_tales

Shiloh and Savannah were adopted as puppies from a rescue organization in the USA, and they moved here when they were two years old. They have lived in London for five years now, and they enjoy traveling throughout Great Britain from Dover to Wales, from Lands End to Inverness, and everywhere in between. Their favorite activities in London are taking in the views while riding the DLR, hanging out in the pubs, and most of all chasing squirrels around Greenwich Park!

DJ
Boston Terrier
Charing Cross Road

@dj_bostonterrier
Life, according to
DJ, is all how
you look at it.

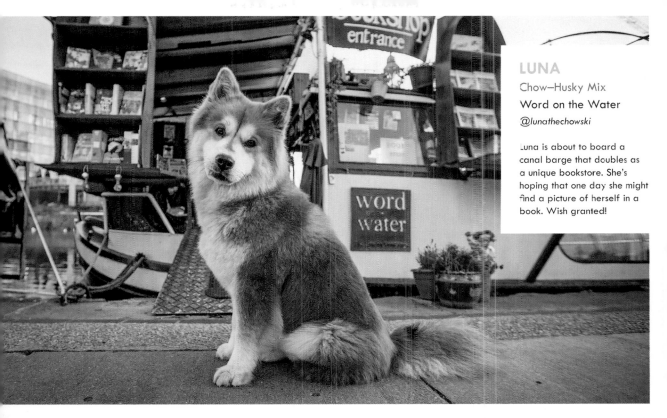

LUNA
Chow—Husky Mix
Word on the Water
@lunathechowski

Luna is about to board a canal barge that doubles as a unique bookstore. She's hoping that one day she might find a picture of herself in a book. Wish granted!

ZOLA
Mixed Breed
Soho
@gorgonzolathaidog

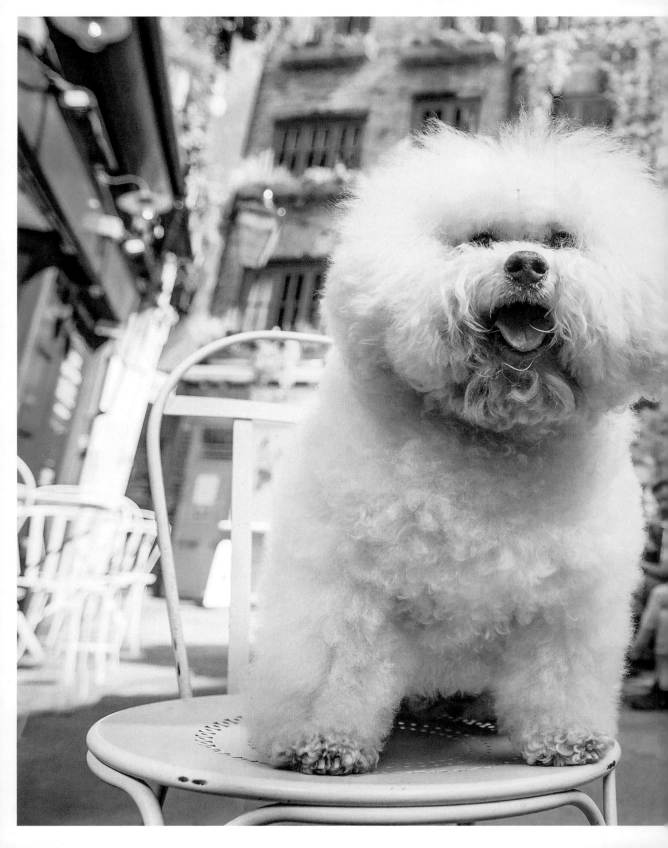

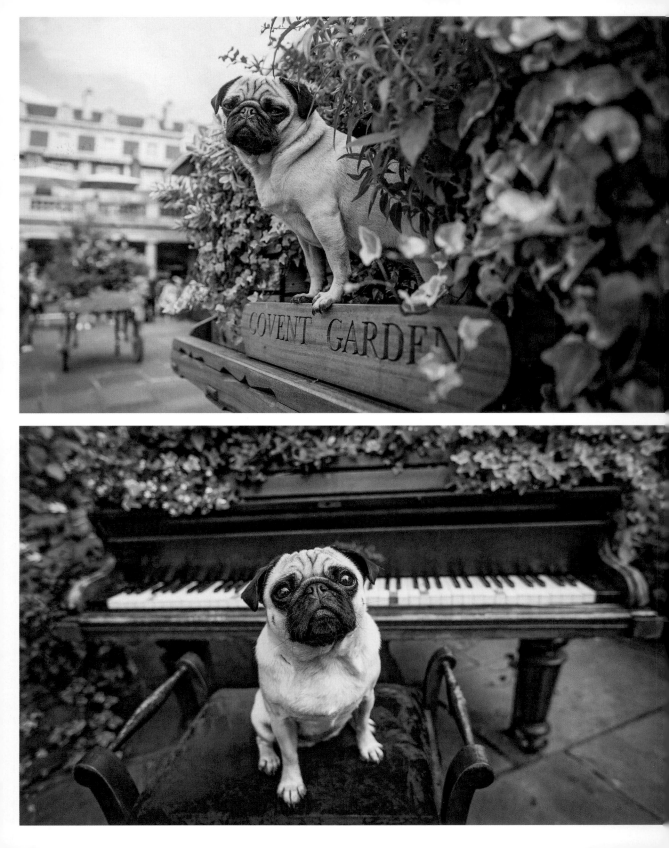

LILLY
Pug
Covent Garden
@Little_lil_pug

Due to her petite size and youthful looks, Lilly is constantly mistaken for a puppy. But that doesn't bother her a bit! She's happy to be forever young.

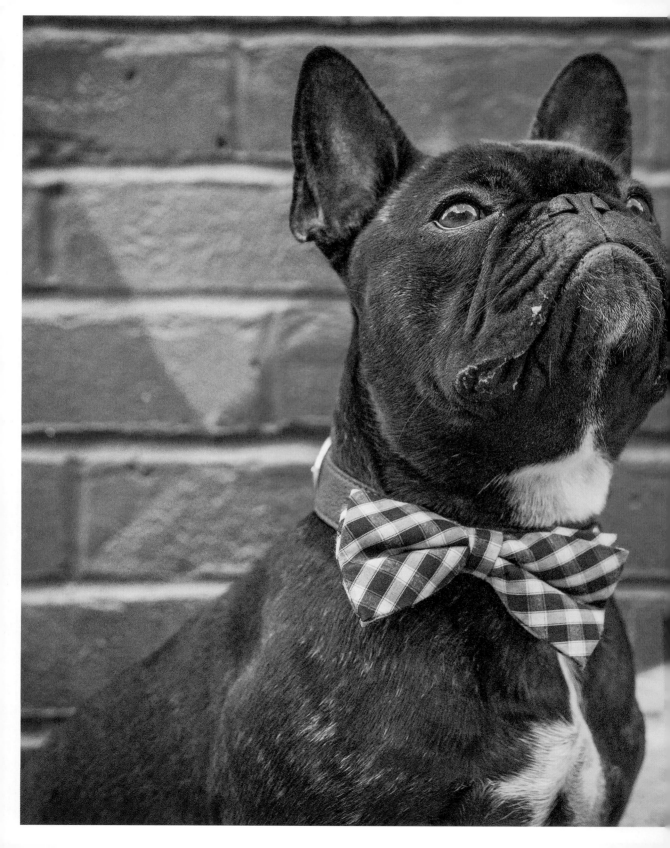

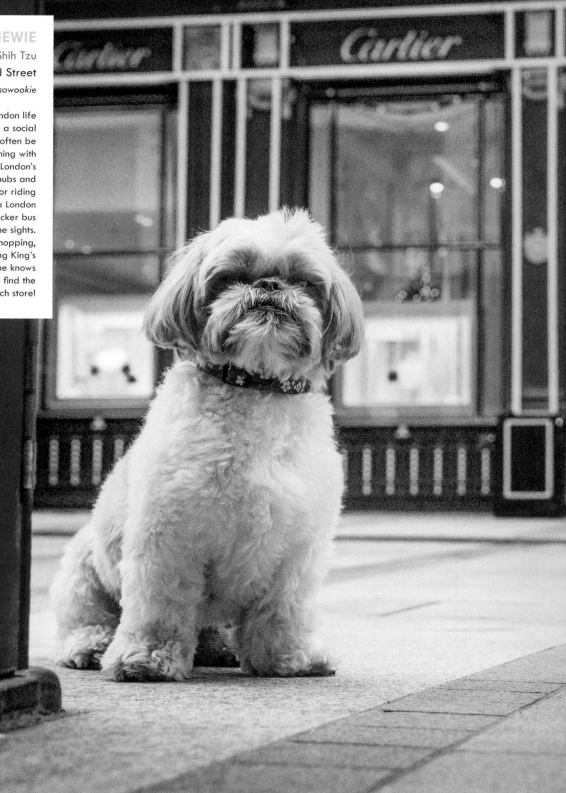

CHEWIE
Shih Tzu
Old Bond Street
@chewiesawookie

Chewie loves London life and is a bit of a social butterfly. He can often be spotted brunching with his friends in London's dog-friendly pubs and restaurants, or riding on the top of a London double-decker bus looking out at the sights. He enjoys shopping, especially along King's Road, because he knows exactly where to find the treats in each store!

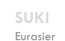

SUKI
Eurasier
Shoreditch

Pretty little Suki is convinced she's a human. Her owners say she will bounce babies in their baby bouncers with her paw. In the evening, it's her turn—she demands tummy rubs.

GEORGIE
Alaskan Malamute–Keeshond Mix
Shoreditch

Georgie says "no thanks" to the fish and chips. She much prefers broccoli and blueberries. She has no clue how big she is and thinks she can squeeze into tiny spaces—sometimes she gets quite stuck!

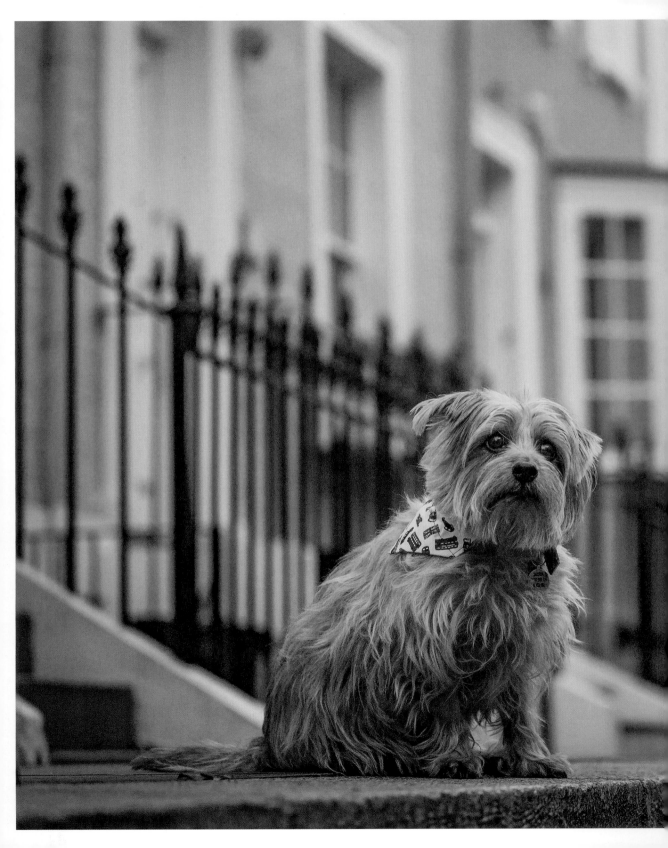

ARCHIE
West Highland Terrier
Chelsea
@the4leggedfoodie

Archie helps his human find all the best dog-friendly places in London to visit with four-legged friends—pubs, restaurants, and events.

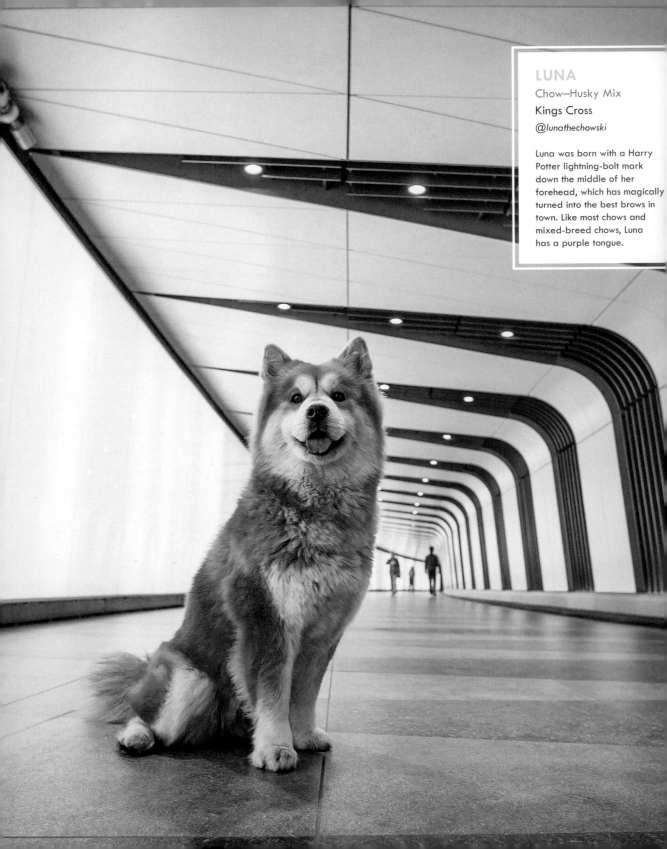

LUNA
Chow–Husky Mix
Kings Cross
@lunathechowski

Luna was born with a Harry Potter lightning-bolt mark down the middle of her forehead, which has magically turned into the best brows in town. Like most chows and mixed-breed chows, Luna has a purple tongue.

SHILO
Spaniel Mix
The Gherkin

BETSY
Mixed Breed
Horseferry Road

SAVANNAH
Spaniel Mix
The Gherkin

LYCHEE
Cockapoo
Lovat Lane
@tailoflychee

She's still a puppy—just six months old—but Lychee is already a major foodie. She will not let you forget that you owe her a treat after every one of her tricks. She posed nicely for me here, but she's a social butterfly who wants to say hi to every dog who comes along.

ENY
Pembroke Welsh Corgi

Kyance Mews
@oh_my_corgi_eny

Eny was born in Moscow, but now loves her life in London where she charms everyone she meets. She loves having cookies at teatime.

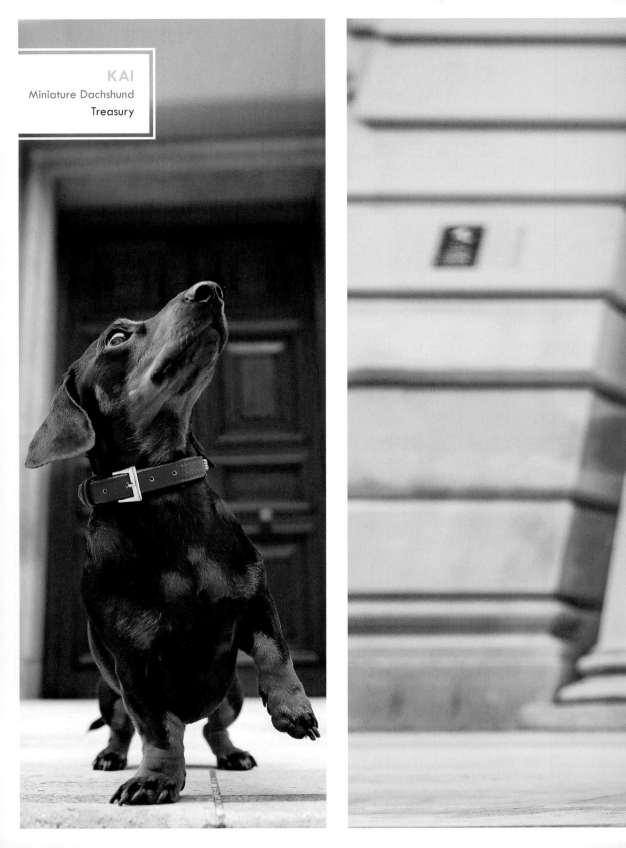

KAI
Miniature Dachshund
Treasury

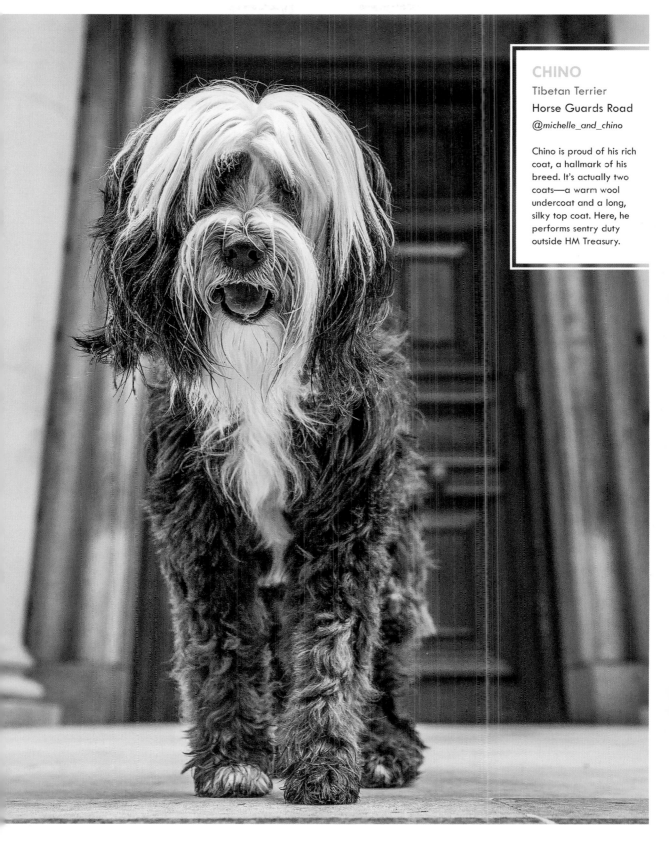

CHINO
Tibetan Terrier
Horse Guards Road
@michelle_and_chino

Chino is proud of his rich
coat, a hallmark of his
breed. It's actually two
coats—a warm wool
undercoat and a long,
silky top coat. Here, he
performs sentry duty
outside HM Treasury.

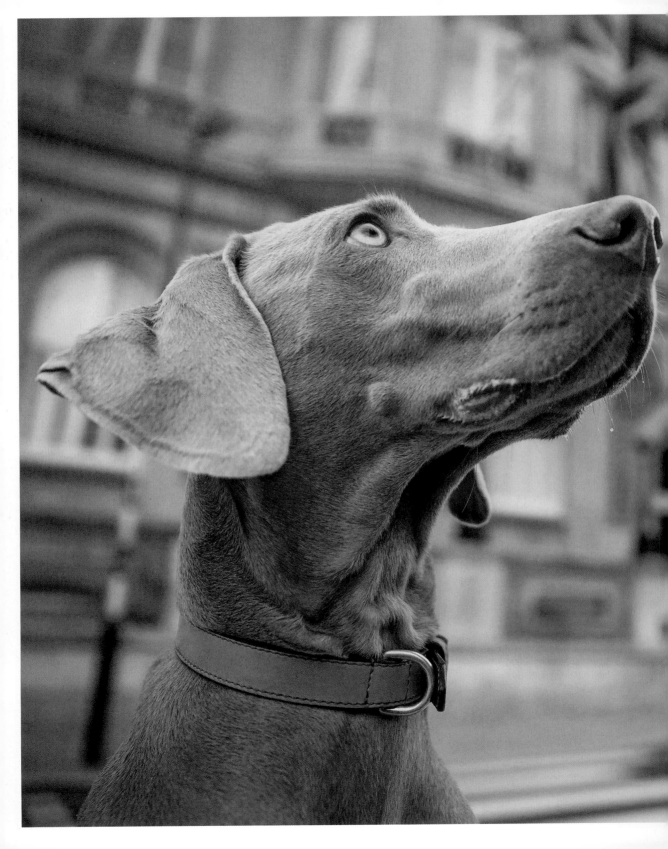

SCOOBY
Saluki Mix
Royal Exchange
@alwaysbescoobin

Scooby is just eighteen months and all smiles when he poses. His breed represents the royal dogs of Egypt. Unlike most salukis, which tend to be shy by nature, Scoob is very friendly and always excited to meet new people. He has excellent sight and can spot a squirrel from the other side of the park. His breed can run up to 40mph (no one has yet to speed-test Scooby!). His favorite sport: chasing a robot vacuum cleaner around the house.

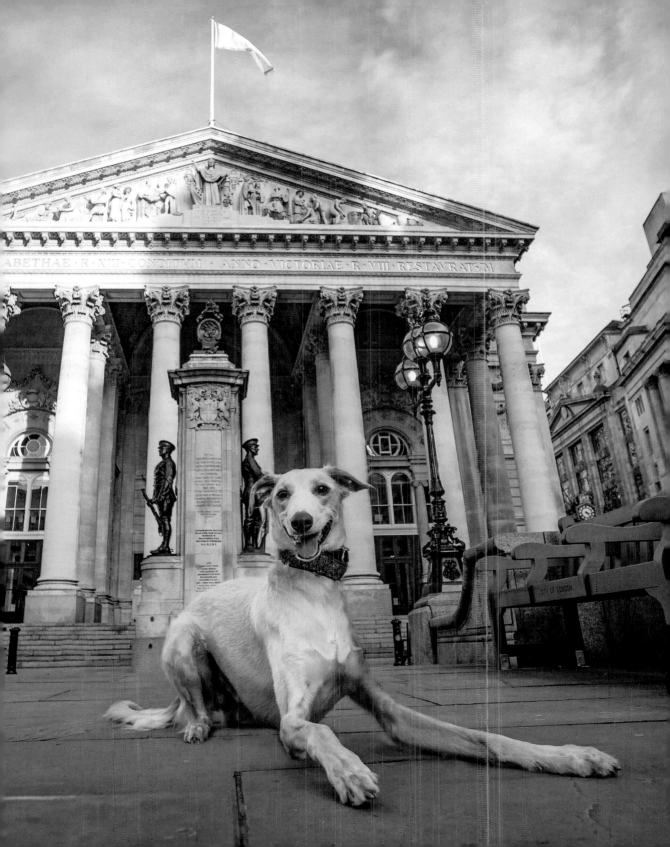

HATTIE
Chihuahua
The Ritz
@hattiekin

Tiny Hattie weighs less than a pound. She often gets mistaken for a squirrel when jumping through the grass in Hyde Park. But her small, nonthreatening size is a boon when she works with children. Hattie is a therapy dog at Great Ormond Street Children's Hospital. She visits pint-sized patients, and also comforts parents and even nurses.

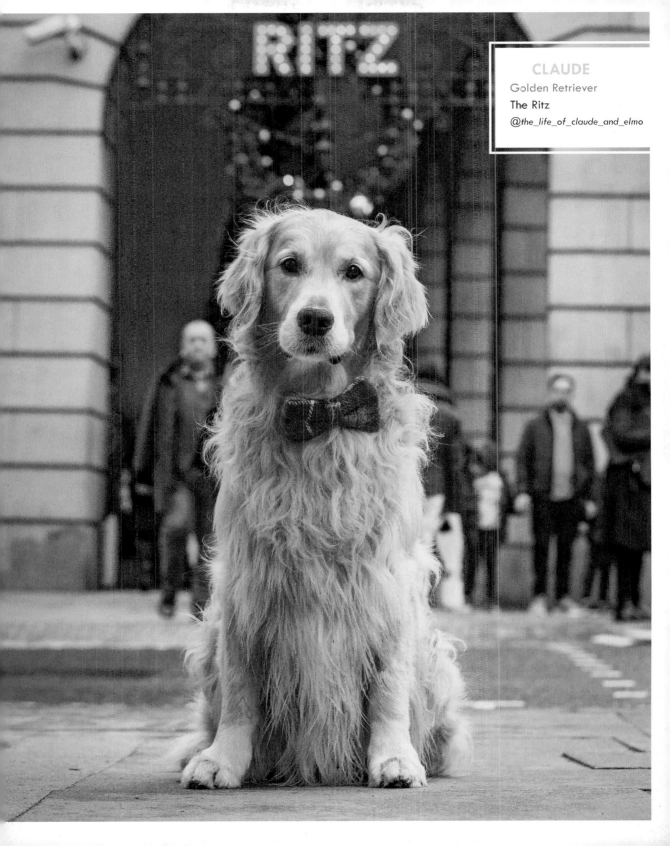

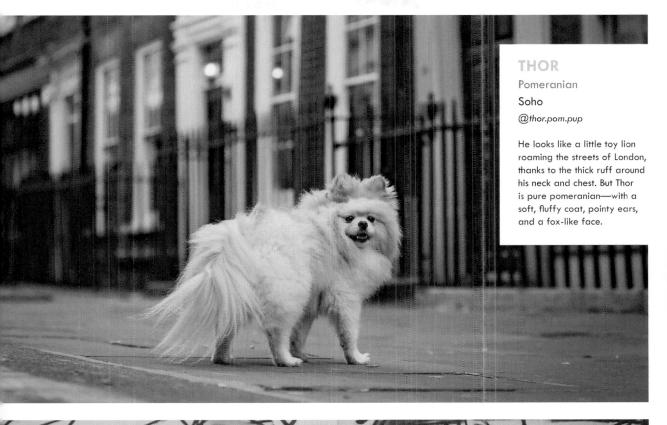

THOR
Pomeranian
Soho
@thor.pom.pup

He looks like a little toy lion roaming the streets of London, thanks to the thick ruff around his neck and chest. But Thor is pure pomeranian—with a soft, fluffy coat, pointy ears, and a fox-like face.

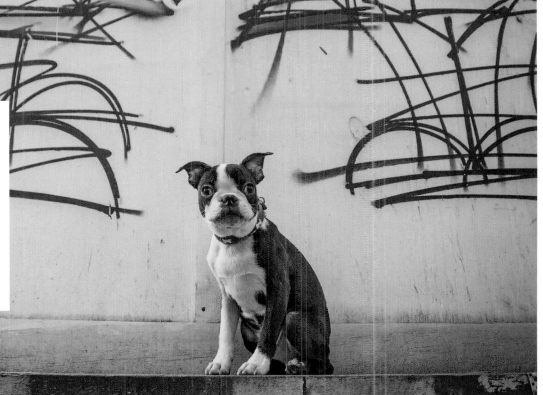

DJ
Boston Terrier
Soho
@dj_boston terrier

This buzzy area is the perfect place to shoot a high-energy dog like DJ. He remained alert to everything going on around him, but kept his eye trained on the camera.

POPPY
Dachshund
Chelsea

Fun-loving Poppy prances about on the streets of Chelsea. She loves chicken and fish and will follow a bouncing tennis ball anywhere.

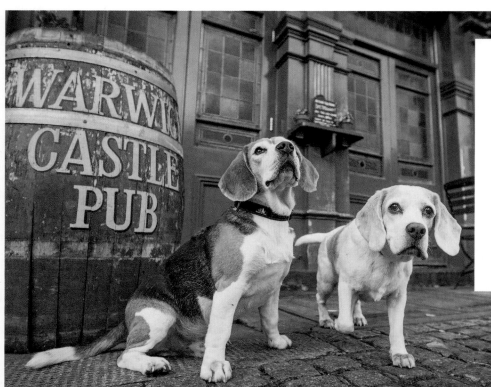

RODNEY and JOHNNY
Beagle
Little Venice

@Rodney_the_beagle_johnnypiglet

Rodney, age seven, and Johnny Piglet, eleven, were both rescued from Beagle Welfare. Johnny is originally from Brazil. A dog psychic once met him and said that Johnny wants to travel Europe in an RV and then retire to Portugal. Sounds like a plan! He's a grumpy old man, but a puppy at heart, and is enjoying learning new skills and tricks all the time.

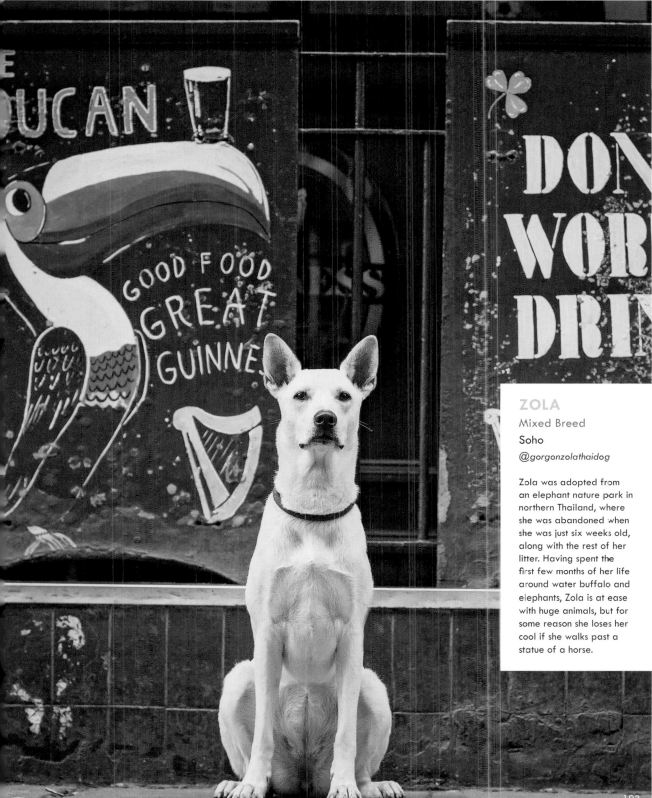

ZOLA
Mixed Breed
Soho
@gorgonzolathaidog

Zola was adopted from an elephant nature park in northern Thailand, where she was abandoned when she was just six weeks old, along with the rest of her litter. Having spent the first few months of her life around water buffalo and elephants, Zola is at ease with huge animals, but for some reason she loses her cool if she walks past a statue of a horse.

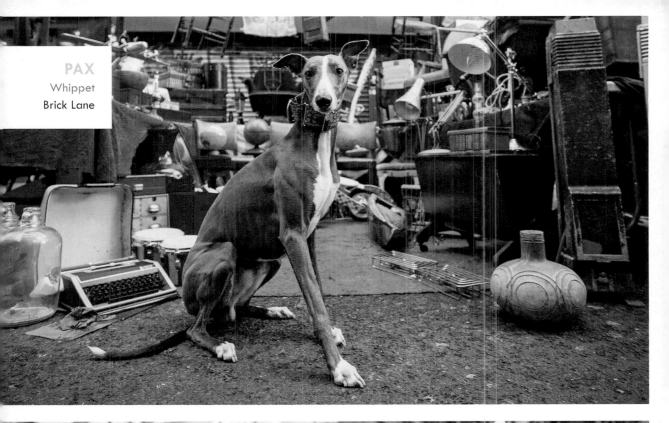

PAX
Whippet
Brick Lane

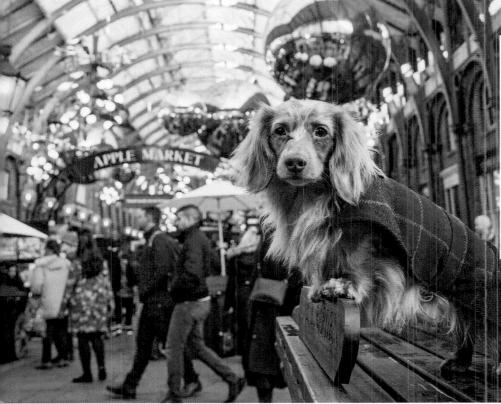

BUDDY
Dachshund
Covent Garden
@buddythedappleddachshund

Buddy doesn't just love food, he worships it. He has a huge personality and a big bark for a little dog (you'll hear it if he doesn't get his way). He's obsessed with cardboard boxes and enjoys nothing more than ripping them to shreds.

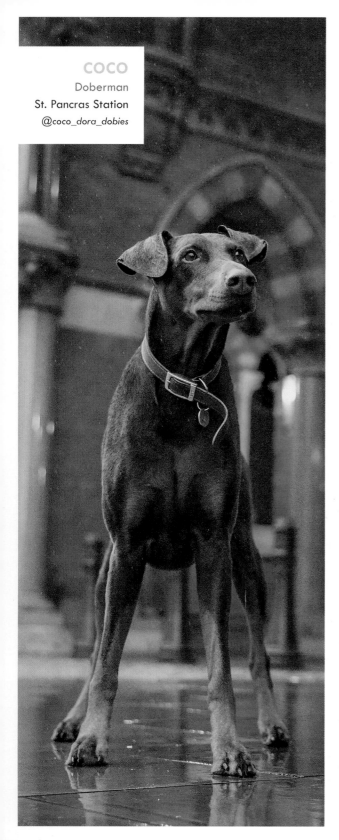

COCO
Doberman
St. Pancras Station
@coco_dora_dobies

ROCK
Bull Terrier
St. Pancras Station
@rockythetraveller

Rocky and his human like to explore the world together—so far, they have traveled to twenty-three different countries. Rocky takes it all in stride—one paw at a time.

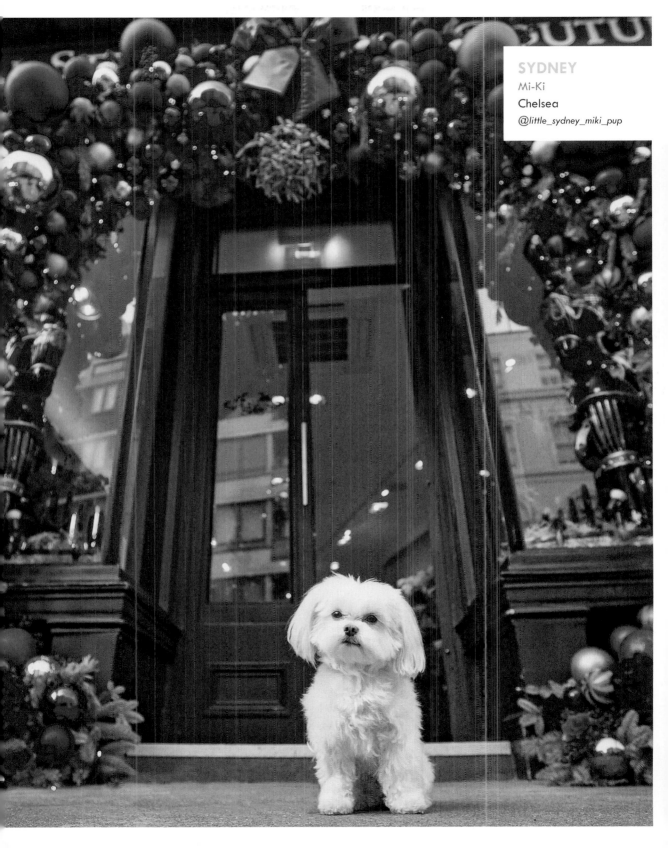

SYDNEY
Mi-Ki
Chelsea
@little_sydney_miki_pup

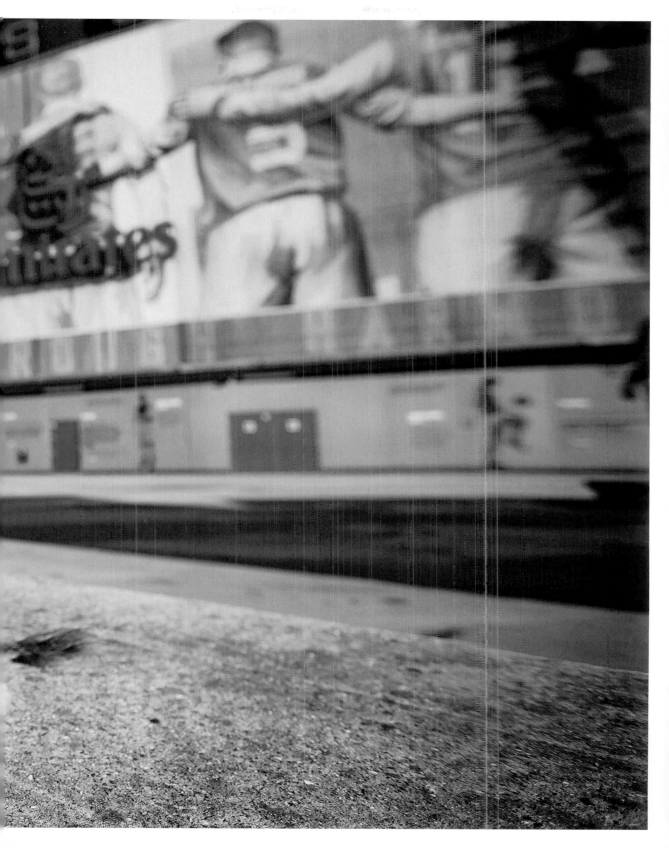

JUNO
Chihuahua
Camden
@Two_little_bugs

Juno is very vocal and
makes different whines
based on what she
wants. Listen up, people!
She will literally tell
you what to do.

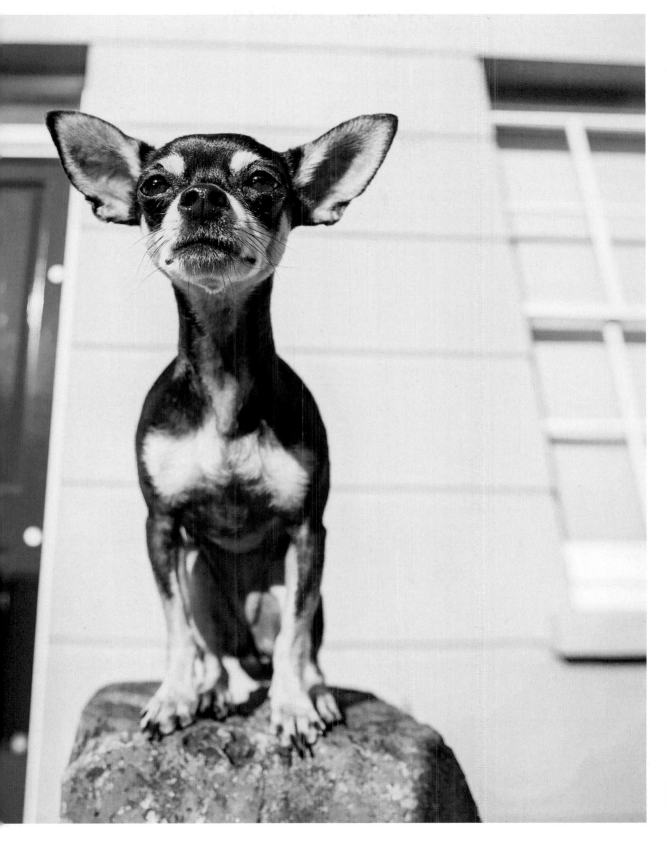

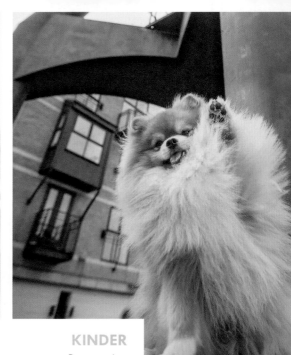

MAGGIE
Boston Terrier
New Scotland Yard
@maggie_bostie

KINDER
Pomeranian
Royal Wharf
@kinderpommy

MAGGIE
Beagle
The Thames

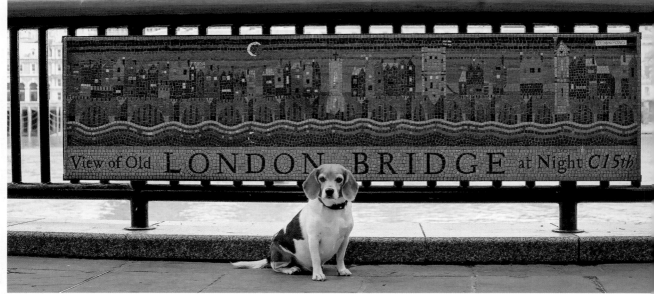

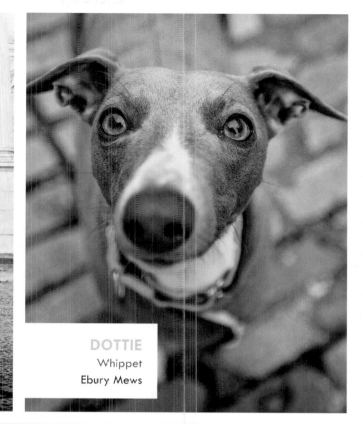

SAIL
Black Labrador
Retriever
Marble Arch

DOTTIE
Whippet
Ebury Mews

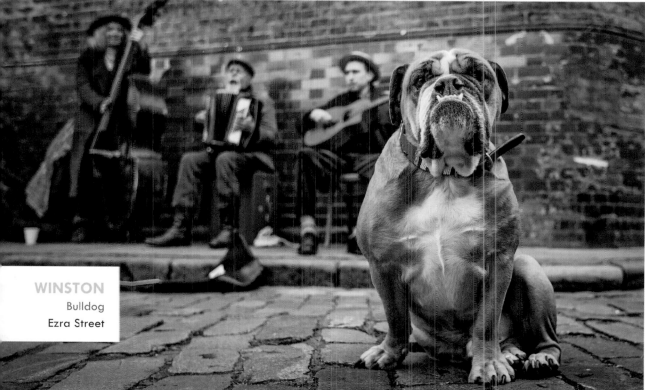

WINSTON
Bulldog
Ezra Street

NEVILLE
Shih Tzu

Greenwich Royal Naval College

Neville is a typical, stubborn shih tzu. He is very loveable and obedient when HE wants to be! His favorite activity is ripping his toys to pieces and making it "snow" all over the living room of his house. He hates water—so it's funny that I chose to shoot him at a naval college. He will do anything to avoid stepping into a puddle with his dainty feet—even if it means balancing on railway sleepers, leaping onto stepping stones, and jumping to other safe, dry areas.

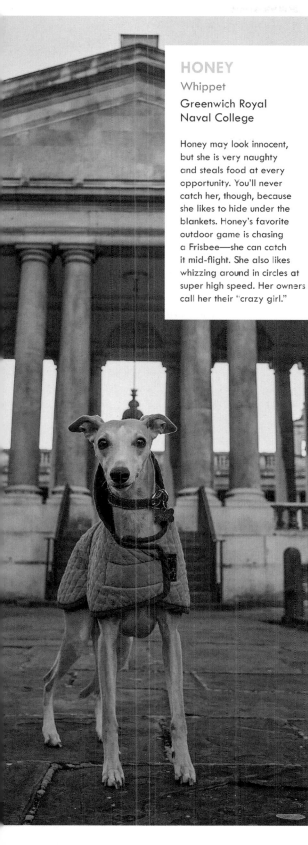

HONEY
Whippet
Greenwich Royal Naval College

Honey may look innocent, but she is very naughty and steals food at every opportunity. You'll never catch her, though, because she likes to hide under the blankets. Honey's favorite outdoor game is chasing a Frisbee—she can catch it mid-flight. She also likes whizzing around in circles at super high speed. Her owners call her their "crazy girl."

MORTY
Pembroke Welsh Corgi
Greenwich Royal Observatory
@morty_thetricorgi

This two-year-old corgi is pretty chill. He likes doing yoga with his human, and has mastered downward dog, side plank cross, and slide. If you'd rather play tug-of-war, though, he's all in.

ALASKA

Chow

Greenwich Royal Observatory

Alaska demands about twenty hours of beauty sleep a day. (She's so pretty—I think it's working.) Sure, she's a little bit of a diva (notice the resemblance to Zsa Zsa Gabor and Liz Taylor), but she's still willing to bounce into a swampy lake with her dog friends. She was one of nine puppies and still has play dates with two of her brothers. Alaska is an extremely fussy eater, but will never turn down peanut butter or cheese.

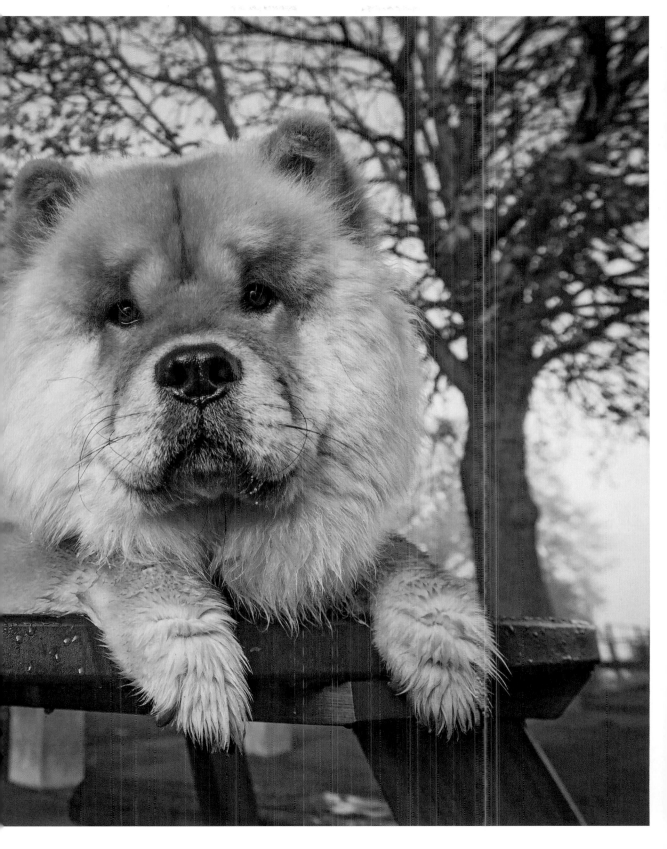

MARLENE
French Bulldog
Shoreditch
@marlenesgang

BUTCH
Bulldog
Primrose Hill

NALA
Miniature Dachshund
The South Bank
@nala.the.dachs

BRIAN
French Bulldog
Shoreditch
@captainbrianthefrenchie

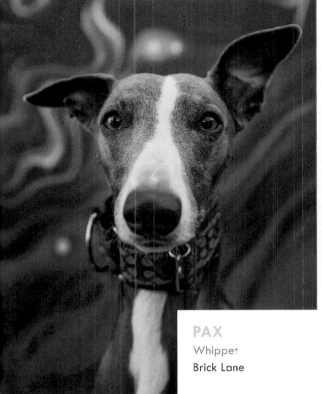

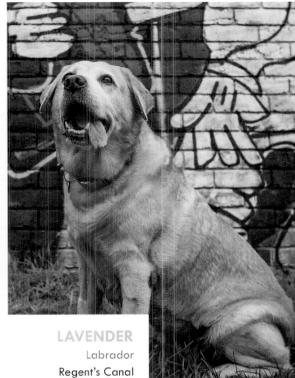

PAX
Whippet
Brick Lane

LAVENDER
Labrador
Regent's Canal

BROCCOLI
Mixed Breed
Camden

SUKI
Eurasier–Alaskan
Mclamute Mix
Shoreditch

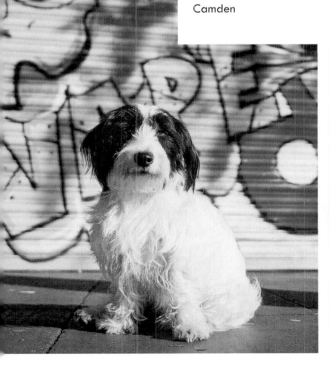

ALFIE
Springer Spaniel
St. Paul's Cathedral Garden

Seven-year-old Alfie is a police dog. But with that impressive mop of hair, he could probably sideline as a member of a Beatles cover band.

JAX
German Shepherd
Wood Street Police Station

There's no greater honor for a German shepherd than to be named a member of the City of London Police. His sense of loyalty and duty are unmatched.

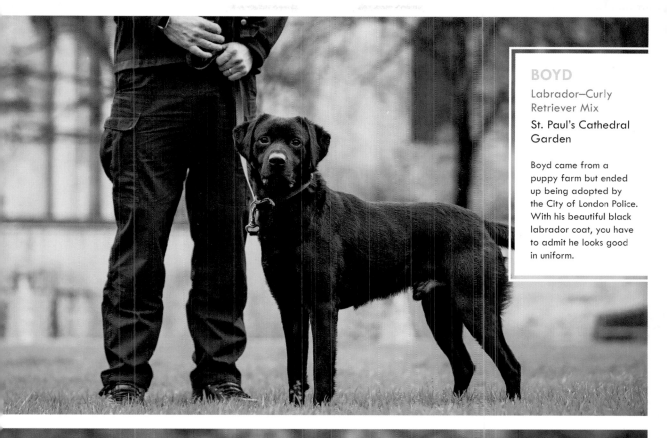

BOYD

Labrador–Curly
Retriever Mix

**St. Paul's Cathedral
Garden**

Boyd came from a
puppy farm but ended
up being adopted by
the City of London Police.
With his beautiful black
labrador coat, you have
to admit he looks good
in uniform.

ROGER

Springer Spaniel

**St. Paul's Cathedral
Garden**

Five-year-old Roger
is ready for duty—
alert and attentive to
everything around him.
He has been with the
police force since he
was a puppy. He has
always been quick to
learn the ropes.

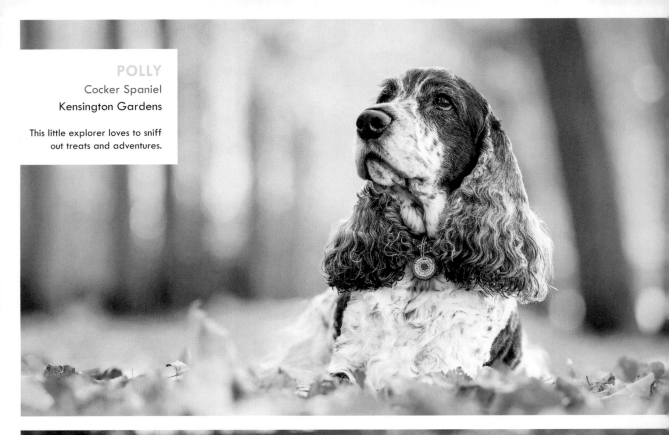

POLLY
Cocker Spaniel
Kensington Gardens

This little explorer loves to sniff
out treats and adventures.

LAVENDER
Labrador
Regent's Canal

Lavender is funny, cute,
sensitive, playful, loving,
and adorable. It's no surprise
she once took fourth place
in a beauty contest.

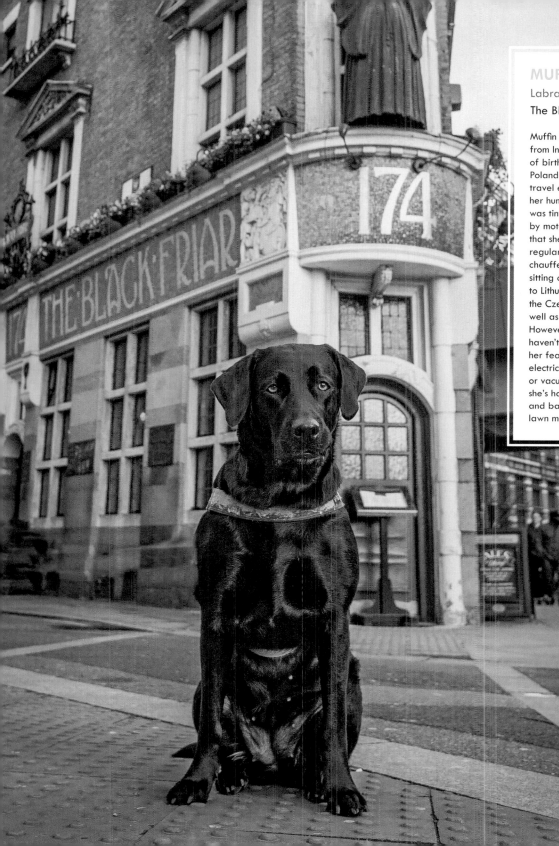

MUFFIN

Labrador

The Blackfriar Pub

Muffin has traveled from India—her place of birth—to London via Poland. She loves to travel everywhere with her human. When she was tiny she even went by motorbike, but now that she's grown, she is regularly seen being chauffeured by car or sitting on a train for trips to Lithuania, Latvia, and the Czech Republic, as well as around the UK. However, all those trips haven't cured her of her fear of cows, goats, electric toothbrushes, or vacuum cleaners. But she's happy to chase and bark at deer or lawn mowers.

CHEWIE
Pomeranian Mix
King's Cross
@wanderingsofawookiee

Three-year-old Chewie was adopted by a family of *Star Wars* fans. His full name is Chewbacca Red Summer and he speaks Wookiee, of course. Red was the color of the collar he was wearing when his humans first met him.

COCO and DORA
Doberman
Queen Elizabeth Olympic Park
@coco_dora_dobies

Princess Coco doesn't like to get out of bed if it's cold and wet. She loves being pampered and enjoys a warm bubble bath and manicure! Dora is her big, goofy sidekick and constant companion. Dora loves to go out—and, unlike Coco, braves any kind of weather!

COLIN

Miniature Schnauzer

**Traffic Light Tree,
Canary Wharf**

@littlecolinschnauzer

This guy is so cute,
he stops traffic! Three-
year-old Colin loves
living in London, but
hates the Central Line.
He'd rather walk.

DOTTIE
Whippet
Belgravia
@country_and_twee

Dottie is the CEO of Country & Twee, which makes elegant dog coats for whippets, dachshunds, and other breeds, as well as bandanas, beds, and treats. She is seen here modeling a cheerful, bright, yellow coat, perfect for a slightly overcast fall day in London.

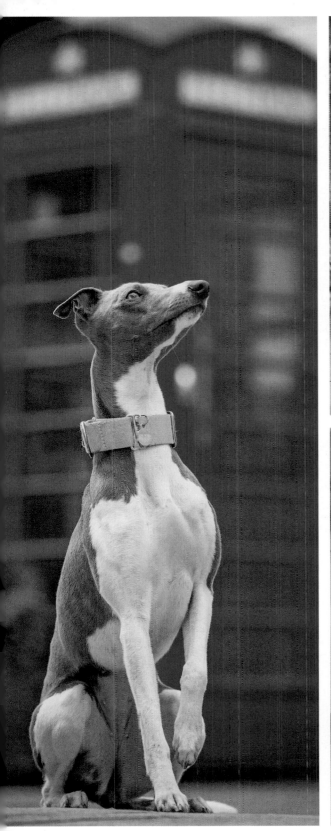
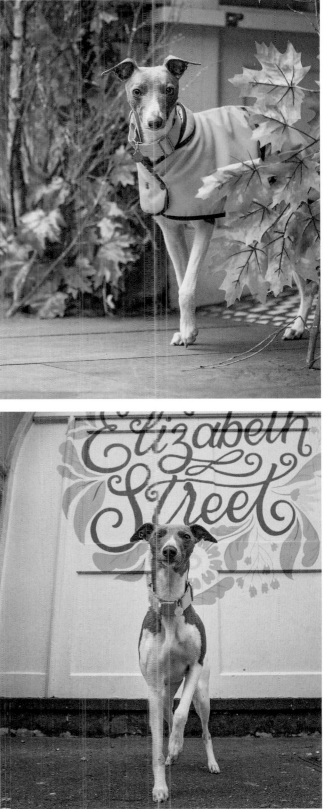

HESTON
Dalmatian

Columbia Road

He loves food, especially poppadoms (thin, crispy, Indian breads). Heston's a patient guy, but don't make him wait for his supper—he will complain loudly!

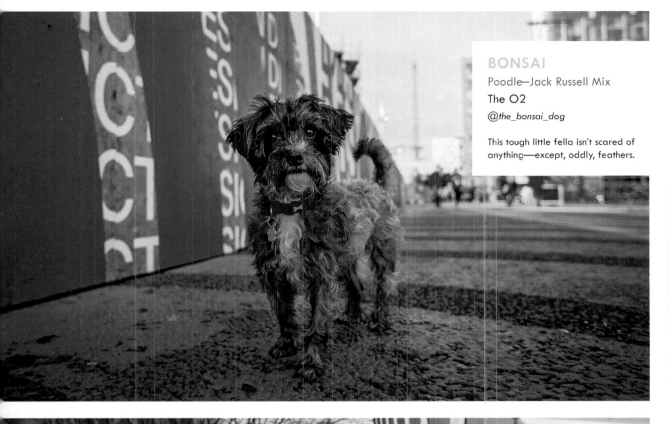

BONSAI
Poodle—Jack Russell Mix
The O2
@the_bonsai_dog

This tough little fella isn't scared of anything—except, oddly, feathers.

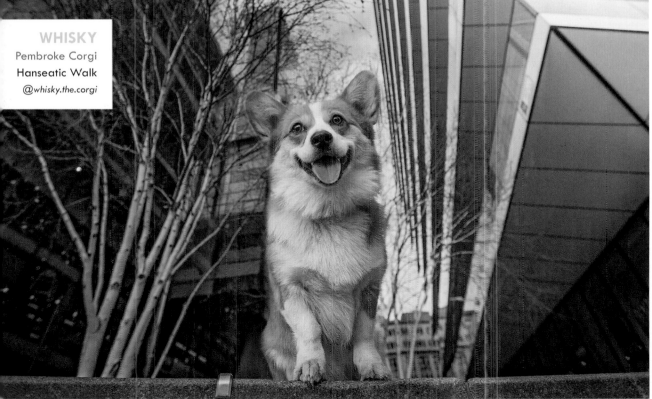

WHISKY
Pembroke Corgi
Hanseatic Walk
@whisky.the.corgi

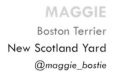

MAGGIE
Boston Terrier
New Scotland Yard
@maggie_bostie

Acknowledgments

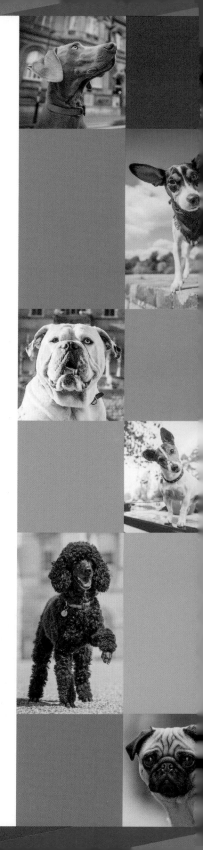

There is a whole world of wonderful dog people out there—along with their fantastic four-legged tail-wagging friends. Thank you to all of them who helped make this book happen. I am so grateful to everyone who took part and answered my model calls. Your dogs are all amazing and you can be so proud of them. This book would simply not be possible without you. Thank you for traveling to London, fighting rush hour traffic, braving the rain and muddy dogs, and showing up early on Sunday mornings. And thanks to the city of London—it's the most amazing town! I could not have wished for a better location for my first book.

I owe a huge debt of gratitude to my wonderful husband, Neil. Not only did he support me over the years with my photography business, but he also encouraged me to work on this book. He listened to me plan all the shoots, and he looked after our own dogs so I could go out and take pictures of other people's. Neil supported me when I doubted myself and stopped me from over-planning (something I tend to do). Neil, thank you for all your support and for listening. I love you lots.

Thank you also to my dad. He is the reason I am a photographer. As a kid, we went chasing steam trains in Germany with my very first camera. It was a film camera and I loved capturing my adventures with it. My dad and my mom told me I could do anything if I worked hard for it. And so, that's what I did. I had a dream of doing a book with dogs in London. I worked hard for it, and now here it is: *Canines of London*!

To Ellen Dupont, my wonderful editor from Toucan Books in London, thank you so much for giving me this amazing opportunity to showcase London and its dogs. Thank you, also, to Julie Brooke, my second editor, and to Dave Jones, who designed these wonderful pages. Thank you to Roger Shaw from Weldon Owen for trusting me to photograph this book, the third in their series showcasing dogs in big cities. And thank you to Antonia van der Meer who helped me write the fun captions that introduce you to each of my furry friends. The idea for this book started back in September of 2020, and I started shooting officially in October. At first I wasn't sure I could get enough dogs to be a part of this in the time we had. But thanks to friends and social media, word went out and tons of people responded. When you look at the photos and see their names, make sure to check them out on Instagram, follow their *pawsome* adventures, and give them a *woof*.

Last, but not least, thank you to my Barka family. The Barkas are a group of dog photographers from all over the world. We share dreams and ideas, and are always happy to support each other, across countries and beyond borders.

Awoof,

Bridget and The Beagles
www.bridgetdavey.com